WHISTLER

Whistler

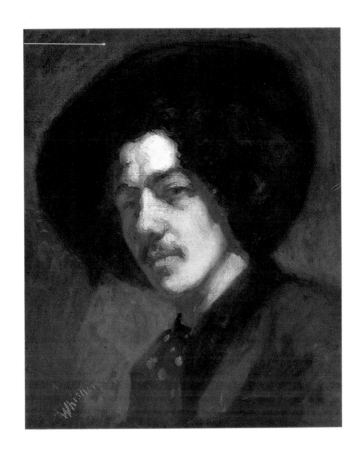

by Pierre Cabanne

CROWN PUBLISHERS, INC. - NEW YORK

Title page: PORTRAIT OF THE ARTIST WITH A HAT, 1857-58
Oil on canvas, 18¼″ × 15″ (46.3 × 38.1 cm)
The Freer Gallery of Art, Smithsonian Institution, Washington, D.C.

Translated from the French by:
NICHOLAS MAX JENNINGS

Series published under the direction of:
MADELEINE LEDIVELEC-GLOECKNER

Editorial research
MARIE-HÉLÈNE AGÜEROS

Library of Congress Cataloging in Publication Data

Cabanne, Pierre.
 Whistler.

 Bibliography: pp. 94-95
 1. Whistler, James McNeill, 1834–1903. 2. Artists–
United States–Biography. I. Title.
N6537.W4C33 1985 760′.092′4 [B] 85–9993
ISBN 0–517–55726–6

and Stéphane Mallarmé, of Gustave Courbet and Dante Gabriel Rossetti, of Count Robert de Montesquiou and Oscar Wilde. His *Nocturnes* provided inspiration for Claude Debussy's music, and he was one of the models for the painter Elstir in Marcel Proust's novel.

After his death in 1903, Whistler's reputation underwent a long purgatory. Perhaps Whistler was deprived of some of the attentions of posterity because he did not struggle with poverty or display the mental anguish that turns the artist into a hero. The critics accept artists who achieve the highest honors, but they can be unforgiving of those who merely enjoy wordly success and a ready, fashionable audience. It was unfortunate that Whistler was never able to shed the image of the dandy. Whether good-natured or proud, Edouard Manet, Edgar Degas, Auguste Renoir, and Paul Cézanne cut figures more familiar to the bourgeoisie, who could identify with them, with their circumstances, their families, their bearing, and even their dress. Quite apart from his mannerisms and his provocative behavior, Whistler, with his ample mane of black hair in which a white forelock stood out, his monocle held by a broad silk ribbon, his piercing eyes, his slender, defiant profile, appeared like a musketeer who had adopted an American accent for exotic effect. He had the reputation of being difficult. Such a reputation can harm an artist, unless, as was the case with Degas, or later with the writer Paul Léautaud, such behavior conceals some inner tragedy, a bitter loneliness, and an uncompromising commitment to art itself.

Whistler was born an American—in 1834, in Lowell, Massachusetts—but he spent the greater part of his life in London and regarded himself as a Parisian. This reflects another oddity in his character, which may be summed up as an evasiveness in the face of binding commitments. This restless man was in constant search of a personal voice somewhere between the creativeness that was the hallmark of Manet or Degas and a preoccupation with elegance and style, which was so pleasing to his vain and decadent friend Count Montesquiou and to Proust. The latter, after

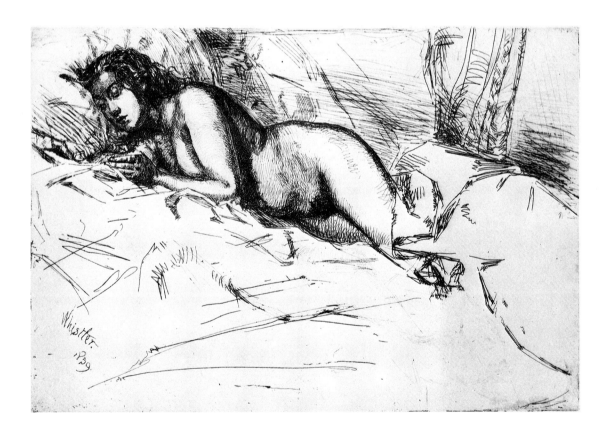

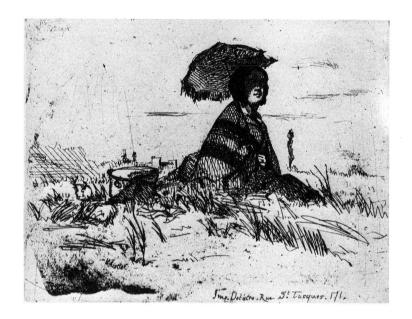

« En Plein Soleil »
(In Full Sunshine), 1858
Etching, II/II, 3⅞" × 5¼"
(10.1 × 13.3 cm)
The Metropolitan Museum of Art
New York
The Harris Brisbane Dick Fund

attending the 1905 Whistler retrospective exhibition, went into ecstasies over « Venice in turquoise, Amsterdam in topaz, and Britanny in opal.» As he put it, these glorious landscapes left him in a terrible, inexpressible state of nervous agitation. The technical demands and aesthetic preoccupations of Claude Monet and Cézanne would not have moved him so.

From there to say that Whistler's art really belonged to the world of letters—the world of Mallarmé, who translated his «Ten O'Clock» lecture into French, of Oscar Wilde, Edmond de Goncourt, who was actually more sarcastic than admiring, J. K. Huysmans, Henry James, Montesquiou, and Proust—there would be only one step. But this would be going too far, even though he was indeed adopted by the Symbolist writers. Whistler was attracted by Symbolism, fascinated as he was by everything that could suggest a world other than the one he lived in. He loved the dreamlike quality, the contrived and precious style, the paradox, the spell of nocturnes and symphonies, the decorative mannerisms and the spiritual preoccupations of Symbolist literature and music. He found the Symbolists more modern than the Impressionists, who were too naturalistic for his taste. He shared with the Symbolists a preference for decorative effects that were derived from the design and composition of Japanese prints, thus meeting the preoccupations of the English Pre-Raphaelites and announcing those of Art Nouveau. Whistler defined modern art as a homage to Beauty—to a powerful and superior mystery that he worshiped with all his fervor, and to which he brought his rich sensitivity, his disdain for anything vulgar, and his search for a certain quality in art. Art was to be dreamlike, magical, poetically suggestive, the antithesis of labor.

In any recollection of Whistler's life, it is difficult to overlook the position occupied by his friend Robert de Montesquiou,* whose dubious reputation still casts a shadow over Whistler's. He gave Whistler moral support (if that is the word) in his determination to be above the rabble. He held the dangerous idea that art and taste are essentially one and the same thing. He was almost as famous in his day as Whistler for improbable and provocative sallies. He certainly contributed to

* Montesquiou, himself a poet and a writer, was an admirer of Gustave Moreau. He probably was a model for Charlus in Proust's «Remembrance of Things Past» and for Des Esseintes in Huysmans's «A Rebours.» He introduced Whistler into fashionable Parisian society.

BLUE WAVE, BIARRITZ, 1862
Oil on canvas, 25½″ × 35¼″ (65.8 × 90 cm)
Hill-Stead Museum, Farmington, Connecticut

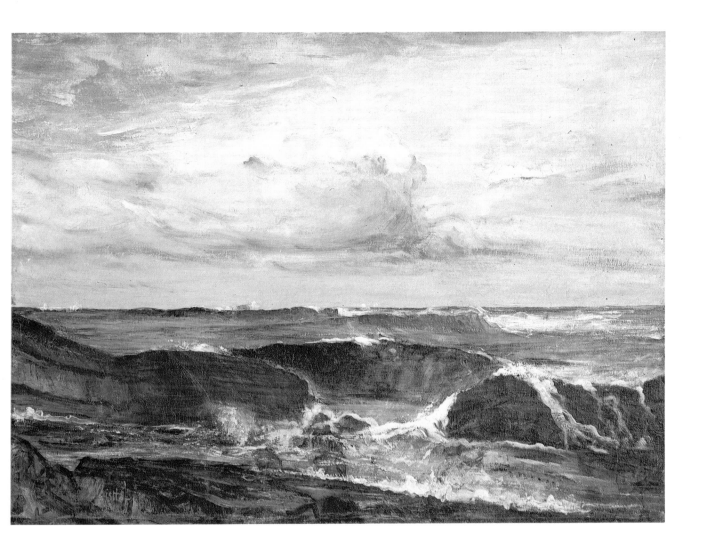

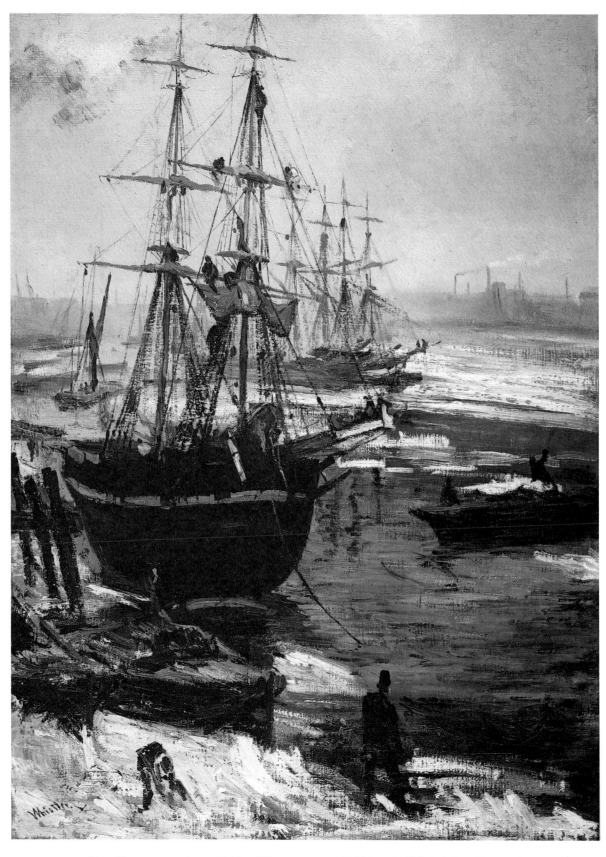

THE THAMES IN ICE, 1860. Oil on canvas, $29^{3}/_{8}'' \times 21^{3}/_{4}''$ (74.6 × 55.3 cm)
The Freer Gallery of Art, Smithsonian Institution, Washington, D.C.

Whistler's reputation as a social butterfly, which clung as much to his art as to his person. Whistler accepted that label, but it is worth looking a little deeper.

Whistler was born into a long-established American family of Scottish and Irish descent. His father, George Washington Whistler, was an extremely successful engineer, a graduate of West Point, who could himself be regarded as the prototype of the cultured Yankee globe-trotter. His mother, Anna Matilda McNeill, was George Washington Whistler's second wife. She was a Southerner and a devout Protestant. Her importance in Whistler's life is vouched for by the fact that he added her surname, McNeill, to his name. Through his family, he belonged to a provincial, military, and puritanical tradition, hence his touchiness on points of honor, his ironical and sometimes brash wit, his feeling that he belonged to an imaginary order of chivalry. This created in him a somewhat anachronistic, idealized vision of the world and of men that was to express itself in his paintings. He was a headstrong man, full of racial prejudices that were eventually subdued by time, and while he had many mistresses and flaunted a fashionable hatred of women, he was of a perverse ambiguity and an exhibitionism characteristic of the times.

James had an older sister, Deborah, from his father's previous marriage, and a younger brother, William. In 1837 his family left Lowell for Stonington, Connecticut, where his father supervised the building of a railway. Later they settled in Springfield, Massachusetts, and in 1843 they left for Russia, where his father was to help build the railway between Moscow and St. Petersburg. There James lived in the lap of luxury surrounded by household servants. He had a private tutor and took lessons in drawing and French. Later he took classes in drawing at the Imperial Academy of Sciences, where he was noticed for his talent.

At the Hermitage Museum he had the opportunity to study the works of Velázquez, who was to be one of the major influences in his painting. In 1847 and 1848 he visited his sister Deborah, who had been living in England since her marriage to Francis Seymour Haden, a surgeon and a skilled engraver. In London, Sir William Boxall painted his portrait, which was exhibited at the Royal Academy of Arts in 1849. This completed Whistler's conversion: he wrote to his father in St. Petersburg that he wanted to become a painter. His father died very shortly afterward. Whistler's family returned to the United States, suffering from acute financial difficulties. He agreed to become a cadet at West Point, but it quickly became apparent that he was not suited for a military career. In 1853 he was dismissed because of his poor academic record and his demerit points (only in drawing was he at the top of his class). Friendly connections found him a job at the U.S. Coast Survey Office, and this marks the beginning of his career as an etcher. However, he did not like working for the Coast Survey Office and he was soon dismissed. Having read Henri Murger's «Scenes from Bohemian Life,» which portrayed the life—particularly exotic when seen from America—of art students and working girls in Paris, he pleaded with his family to let him go and lead that carefree life in Paris. On November 3, 1855, Whistler arrived in Paris, with an allowance of three hundred-and-fifty dollars from his family, and he never again set foot in the United States.

BETWEEN THE PRE-RAPHAELITES AND COURBET

This is how Whistler was remembered in 1905 by the painter and essayist Jacques-Emile Blanche—a bad painter but a very good essayist:

> Among my earliest memories, I still remember the name of Whistler being bandied about by the men who posed for Fantin-Latour, next to Manet and in front of Delacroix's portrait. At the back of the artist's studio in the Rue des Beaux-Arts could be seen the *Homage to Delacroix*, in which a slim, dandified figure squeezed into his long frock coat, with a white

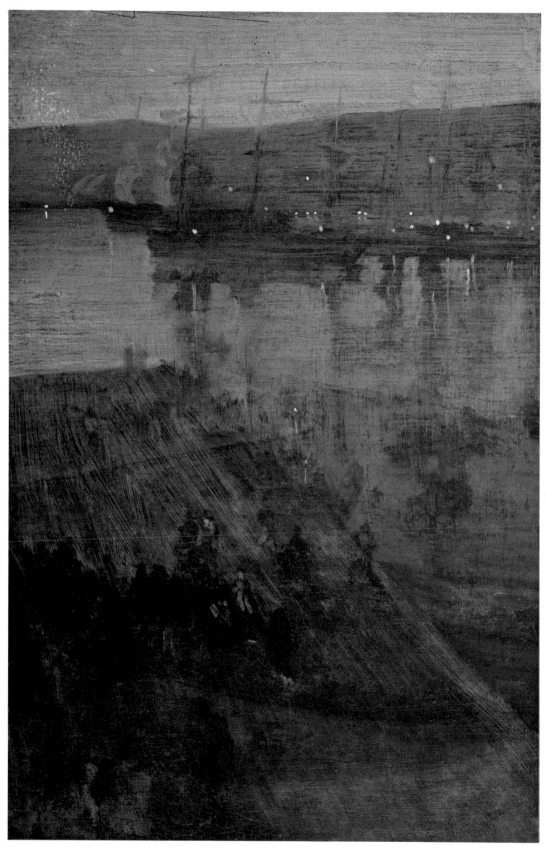

NOCTURNE. BLUE AND GOLD: VALPARAISO, 1860-61
Oil on canvas, 37⅝″ × 27⅞″ (95.5 × 70.8 cm)
The Freer Gallery of Art, Smithsonian Institution, Washington, D.C.

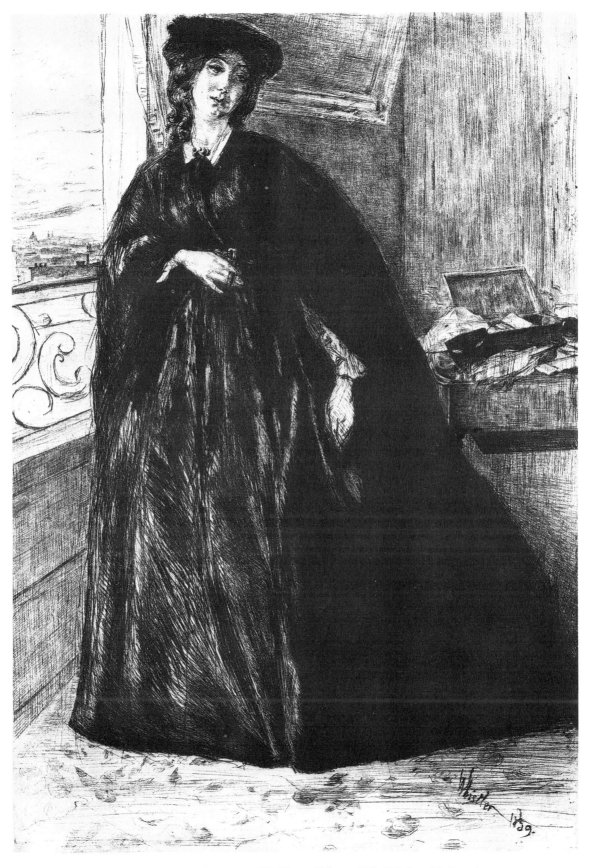

Finette, 1859. Drypoint, IX/X, 11⅜″ × 7⅞″ (28.8 × 20.1 cm)
The New York Public Library. Astor, Lenox and Tilden Foundations

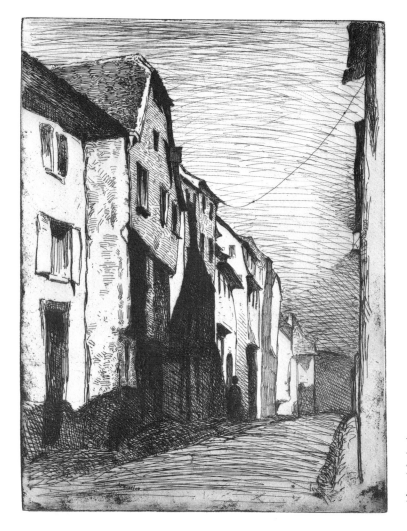

forelock standing out against curly black hair, a monocle, and an ironic mouth, turned toward the viewer.... This curious character intrigued me for a long time.... In his day, this «Young Whistler» was an unconventional kind of American.... He quickly vanished from the scene after a promising start. *

That judgment was superficial and a little premature. Just a few months before Henri Fantin-Latour painted his *Homage to Delacroix*, Baudelaire wrote a critical notice of some prints by Whistler that were to be published later in *The Thames Set*, in an unsigned article which first appeared in the April 2, 1862, issue of «Revue anecdotique» and was reprinted in the «Boulevard» five months later:

Just the other day a young American artist, Mr. Whistler, was showing at the Galerie Martinet, a set of etchings, subtle, lively as to their improvisation and inspiration, representing the banks of the Thames; wonderful tangles of rigging, yardarms and rope, a hotchpotch of fog, furnaces and corkscrews of smoke; the profound and intricate poetry of a vast capital. **

* Jacques-Emile Blanche. *De David à Degas*. Paris, 1927.
** Charles Baudelaire. *Art in Paris, 1845-1862*. Trans. by Jonathan Mayne. London: Phaidon, 1965, p. 220.

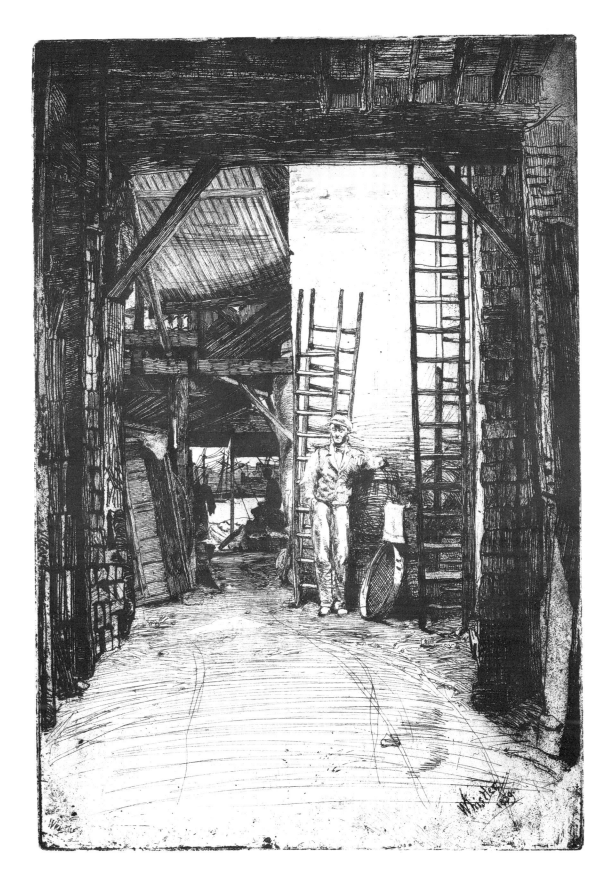

15

« La Vieille aux Loques »
(Old Woman with Rags), 1858
Etching, III, III, 8⅛" × 5¾" (20.8 × 14.7 cm)
The Metropolitan Museum of Art, New York
The Harris Brisbane Dick Fund

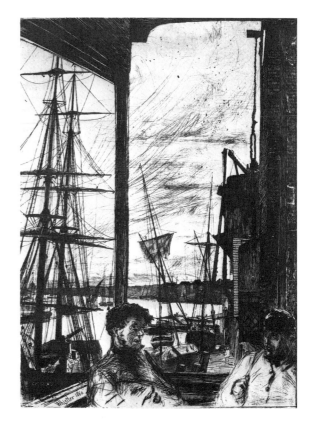

Rotherhithe, 1860
Etching, II/III, 10¾" × 7¾" (27.5 × 19.9 cm)
The New York Public Library
Astor, Lenox and Tilden Foundations

16

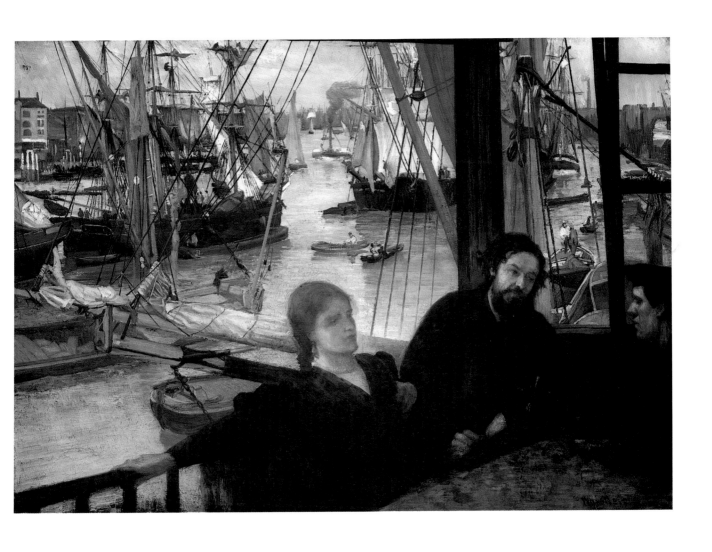

WAPPING ON THAMES, 1861-64
Oil on canvas, 28½″ × 40¼″ (72.3 × 102.2 cm)
National Gallery of Art, Washington, D.C.
John Hay Whitney Collection

17

TWILIGHT IN OPAL, TROUVILLE, 1865
Oil on canvas, 13¾″ × 18⅛″ (35 × 46 cm)
The Toledo Museum of Art, Toledo, Ohio
Gift of Florence Scott Libbey

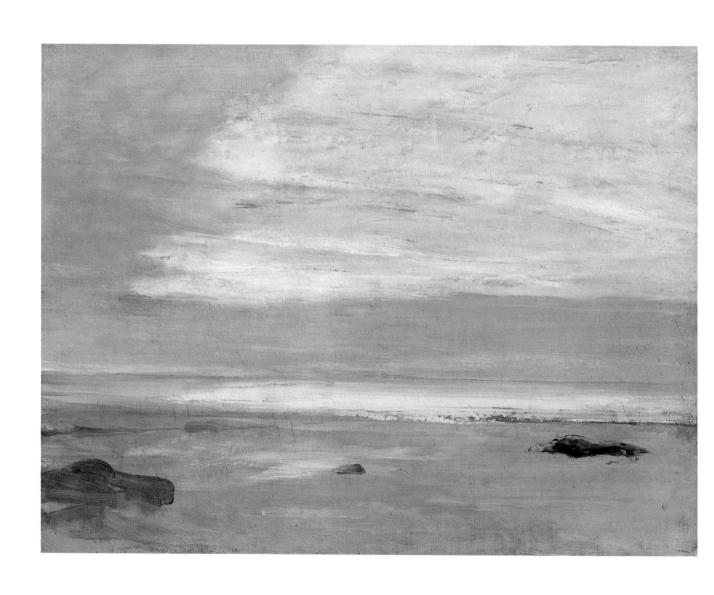

18

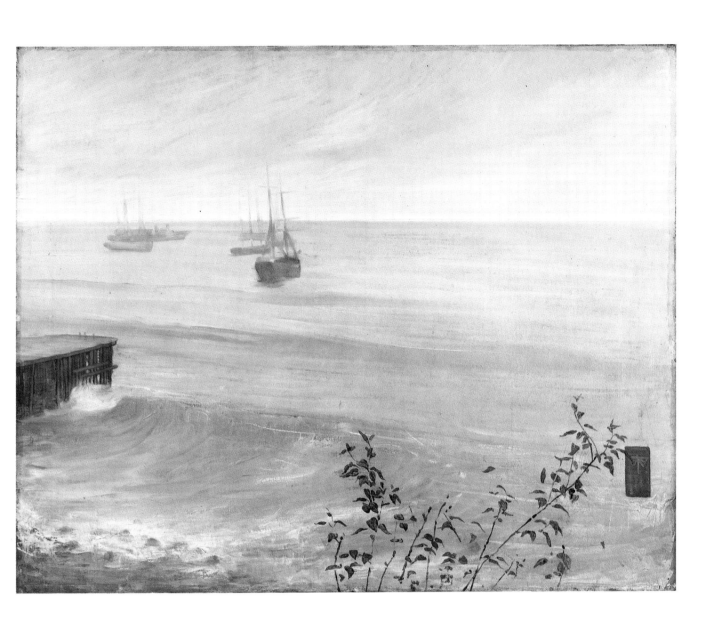

THE OCEAN, 1866
Oil on canvas, 31¾″ × 40⅛″ (80.7 × 101.9 cm)
The Frick Collection, New York

HARMONY IN BLUE AND SILVER: TROUVILLE, 1865
Oil on canvas, $19^{11}/_{16}''$ × $29^{15}/_{16}''$ (50 × 76 cm)
Isabella Stewart Gardner Museum, Boston

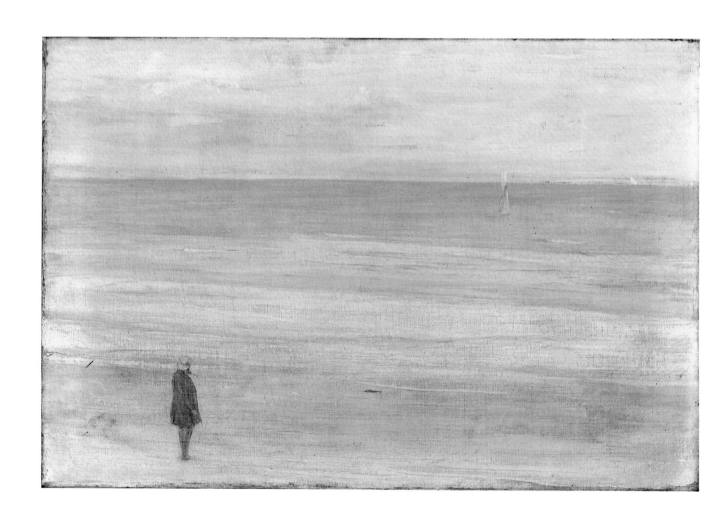

Whistler settled in Paris in 1855. The following year he joined the studio of a Swiss painter, Charles Gleyre, who specialized in ponderous allegorical and mythological scenes. Although he was an academic painter, Gleyre was known for being an interesting teacher: he gave his students a solid grounding and he encouraged them to find their own personal style. There was no real tuition fee; his students needed to pay only for the rental of the studio and the models. His school therefore became a haven for young and needy artists of an independent mind. Whistler immediately took to the Bohemian life he had been looking for in Paris. His eccentric costumes, his restlessness, his turbulent affairs—one of his mistresses was known as «The Tigress» in the Latin Quarter—and his character, which oscillated between venom and affability, quickly set him among the dandies of Paris. In order to earn some money, he accepted commissions to copy works at the Musée du Luxembourg and the Louvre, where he particularly admired Velázquez, whom he had already discovered at the Hermitage and whose work he went to see in Manchester, England, at the 1857 Exhibition of the Treasures of Art. When Whistler was short of money he went to stay with his sister's family in London, which enabled him to visit the National Gallery and other British museums. It was also during this period that Félix Bracquemond introduced him to the art of the Japanese print, which proved to be a decisive influence.

In October 1858, Whistler published his first series of engravings, executed after a journey to Luxembourg, Alsace, and the Rhineland, and dedicated to his brother-in-law, Seymour Haden, who had helped him to perfect his craft during his visits to England. He gave the series the title *Twelve Etchings from Nature* (it is also known as *The French Set*). These etchings were first printed in Paris at the Rue Saint-Jacques by Auguste Delâtre, the printer for the Barbizon painters, and were then published in London the following year. They depict various landscapes and local figures, but they also include a glimpse of the lovely Fumette—whose real name was Héloïse—the «Tigress» of the Latin Quarter. As Katharine Lochnan puts it in her catalogue:

> At first the selection appears to be random, and it is neither «French» nor a «Set» in conventional terms.... The key to understanding the selection may be found in the titles to the set, both published and unpublished.... The chief sources of inspiration which lay behind it were to be found in the avant-garde artistic and intellectual circles in Paris, of which Whistler had become a part.... In selecting and mixing at random portraits of children, friends, the urban working poor, and urban and rural genre, Whistler demonstrated his awareness of the direction in which French art was heading after the Salon of 1857. He selected for inclusion not the most consistent group of etchings which he had made to date, but those which demonstrated the virtuosity of his realist repertoire.... The scenes chosen are characterized by their very banality and by the fact that they could have been found almost everywhere in rural France or Germany.... In addition to revealing an adherence to naturalism in his choice of subjects, Whistler demonstrated his debt to certain painters and etchers, ancient and modern. *

Delâtre was the leading printer in Paris. It was Delâtre who engaged Whistler to find antique paper for his prints. Whistler developed a preference for creamy eighteenth-century Dutch laid rag paper, as well as for *japon mince*, a thin, almost transparent sheet of Oriental paper made from the bark of the mulberry tree. Many prints were pulled on *chine collé*, thin sheets of Japanese paper mounted on to larger sheets of machine made wove paper, which reinforced the

* Katharine A. Lochnan. *The Etchings of James McNeill Whistler.* New Haven and London: Yale University Press, 1984, pp. 57-58.

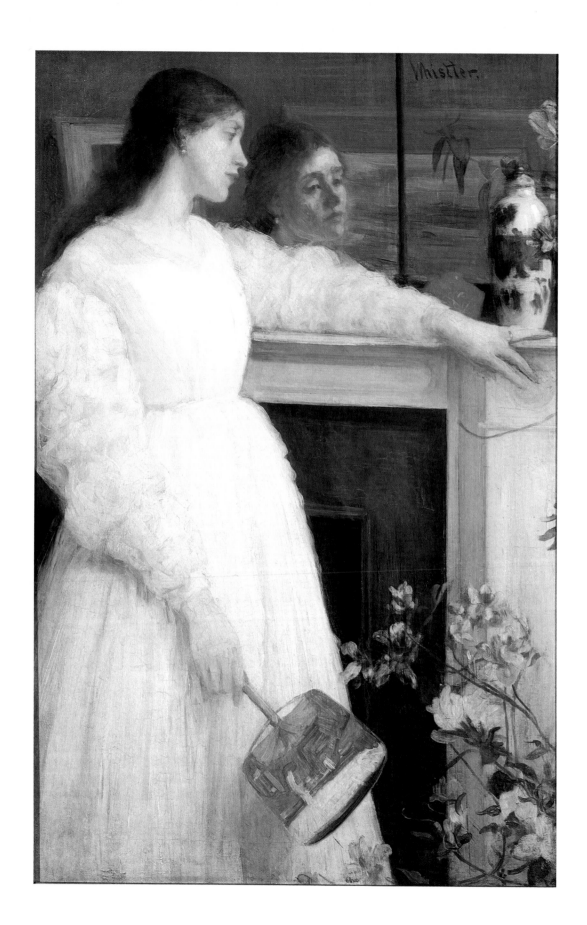

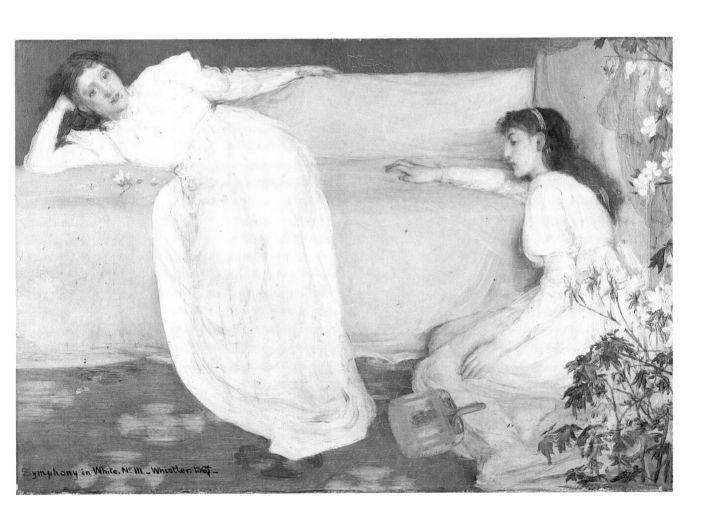

THE LITTLE WHITE GIRL:
SYMPHONY IN WHITE No. II, 1864
Oil on canvas, 30⅛″ × 20⅛″
(76.5 × 51.1 cm)
The Tate Gallery, London

SYMPHONY IN WHITE No. III, 1867
Oil on canvas, 20½″ × 30⅛″
(52 × 76.5 cm)
Barber Institute of Fine Arts
The University of Birmingham, England

23

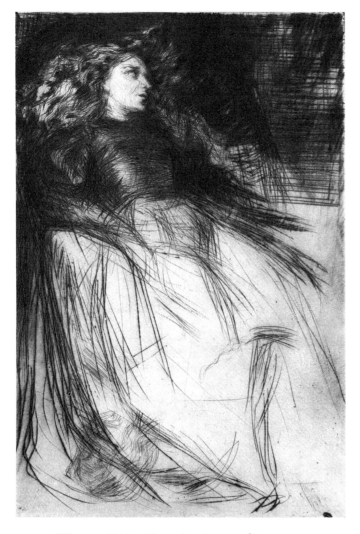

Weary, 1863. Drypoint, intermediate state,
7¹¹/₁₆″ × 5³/₁₆″ (19.5 × 13.2 cm)
The Freer Gallery of Art, Smithsonian Institution
Washington, D.C.

flimsy sheets. Delâtre had studied the chiaroscuro in Rembrandt's prints and he taught Whistler how to achieve different lighting effects by changing the color and the amount of ink he put on the plates.

At the same time, Whistler made the acquaintance of Fantin-Latour, who was copying Veronese's *Wedding Feast at Cana* at the Louvre. Fantin-Latour and Whistler were both admirers of Courbet and this brought them together. Fantin introduced Whistler to the group of Realists meeting at the Café Molière, some of whose members appear in *Homage to Delacroix.* Whistler became interested in the theory developed by Fantin's teacher, Lecoq de Boisbaudran, on training one's visual memory. A meticulous and boring teacher, Lecoq claimed that if you looked deeply and attentively at things, you would be able to depict them faithfully from memory. Lecoq's course at the Ecole des Beaux-Arts was ill-attended, while Gleyre's was sought after because of the atmosphere of freedom that prevailed there. However, it was Thomas Couture, despite his self-important manner, who had the most success. His sarcastic remarks abuot Eugène Delacroix did not deter one of his pupils, Manet, from going to pay his respects to the master, who was then in old age and rather distant despite his fame, and Fantin later took Whistler to Delacroix's studio at the Place Fürstenberg. Both Whistler and Manet can be seen on either side of the aged master in *Homage to Delacroix.* That winter, Whistler did an excellent sketch of Fantin-Latour drawing while lying in bed with all his clothes on and wearing a scarf and top hat because of the cold. It is an amusing snapshot, with the caption: «Fantin in bed engaged in his studies, having difficulties.» At the time, noted Léonce Bénédite, Whistler admired his friend for his «simplicity and breadth» as well as for «the fresh vivid colors which are his specialty.» *

What was he painting at the time? His earliest known painting is the *The Artist's Niece*, which dates from 1849 (Hunterian Museum and Art Gallery, Glasgow University). Annie Harriet Haden, the daughter of his half-sister Deborah, was then about one year old. A few other portraits and landscapes from the period 1850-55 are known to have disappeared, but one surviving

* Léonce Bénédite. *L'Œuvre de James McNeill Whistler.* Paris, 1905.

painting is *Portrait of the Artist Smoking*, probably produced soon after Whistler's arrival in Paris in 1855 (Private Collection, New York). With one remarkable exception, *At the Piano*, few of the works painted in Paris between 1855 and 1859 have come down to us. Of all the copies he made in the Louvre and the Musée du Luxembourg in Paris, only his version of Ingres's *Ruggiero Liberating Angelica* survives—it is now in the Hunterian Museum. Other paintings are a *Portrait of a Peasant Woman* (1855-58), also in Glasgow, which is very thickly painted, with sharp contrasts of light and shadow; an *Interior* (Thomas M. Evans Collection, New York), two portraits of *La Mère Gérard*, probably from 1858-59 (respectively in the Mr. and Mrs. Bernard C. Solomon Collection, Los Angeles, and the Roger S. Phillips Collection). Finally, there is the *Portrait of Whistler with a Hat*, (see title page) in which the critic Théodore Duret detected « the influence of Rembrandt, with whom he had an infatuation at the time »—particularly *Head of a Young Man*, then but no longer attributed to Rembrandt, showing his son Titus with long, curly hair and a broad, floppy beret. In 1859 Whistler painted *Brown and Silver: Old Battersea Bridge* (Addison Gallery of American Art, Andover, Massachusetts). It anticipates the painter's favorite themes and preoccupations. The subject is generously handled, with an attractive delicacy of execution, but without the inventive freedom which the subject later inspired in him.

In November 1858, when Whistler was staying at the Hadens on one of his trips to London, he convinced his half-sister Deborah and her daughter Annie to pose for *At the Piano* (see p. 5), the most ambitious and best painting Whistler had yet painted. Every time he came to stay, his sister tried to keep him in London for good, but he was enjoying life in Paris too much to accept. At the time, a serious artistic career could only be established in Paris. In January 1859, Whistler brought *At the Piano* to Paris. It is a well-composed work and is not unlike the Intimist interiors done by Fantin-Latour at the same time. It should also be compared with Degas's *Belleli Family* of the same year, in which the bold composition shows a complete departure from portraits of academic tradition, and the figures are placed and represented as seen in real life. Whistler's *At the Piano* is tame in comparison, but the harmony of white, greenish gray, and grayish ocher is full of studied refinement and contrasts with the large, flat surfaces of Deborah's black and Annie's white dresses and the maroon of the carpet. The only true innovation in the picture, but a most important one, is the fact that the prints lining the walls are cut off at a quarter of their height in an anti-naturalist manner no doubt inspired by Japanese prints. Such a mixture of traditionalism and innovation was characteristic of the experiments of the young Realists, but the Academy did not appreciate them at all. *At the Piano* was rejected by the Salon of 1859, as were the entries by Fantin-Latour, Alphonse Legros, and Théodule Ribot, who were likewise guilty of allegiance to Courbet.

Another disciple of the master of Realism, François Bonvin, put forward the suggestion that some of the rejected entries should be exhibited at his studio at the Rue Saint-Jacques. He invited Courbet himself to the show, and Courbet was especially struck by Whistler's contribution, on which he warmly congratulated him. The exhibition attracted a number of young painters to whom the portrayal of contemporary life was no less important than the new emphasis on color, in its contrasts and subtle gradations, in preference to line. The interest that Courbet showed in him made such a deep impression on Whistler that he went on a pilgrimage to Ornans, where the great man had grown up and drawn the inspiration for most of his major paintings. He came back overwhelmed. However, the rejection of *At the Piano* by the Salon (although two of his etchings were accepted and shown) made him feel bitter about Paris, and he decided to leave in the spring of 1860 for London, where he set up house at Rotherhithe, next to the Thames, which figures so largely in his work.

Immediately, he addressed himself to the task of persuading his friends to come to London, as if simply by virtue of his presence London had become the artistic center of the world. « England is

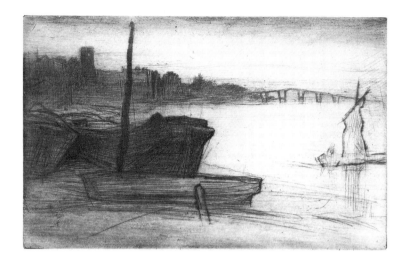

Chelsea Bridge and Church
1870-71
Drypoint, VI/VI
4" × 6⁹/₁₆" (10.2 × 16.7 cm)
The Freer Gallery of Art
Smithsonian Institution
Washington, D.C.

the country which welcomes young artists with open arms,» he wrote to Fantin-Latour. Fantin allowed himself to be persuaded, and came to stay with Seymour Haden. After him came Alphonse Legros and Delaunay, a nephew of Benjamin Constant, whose negligence in matters of dress did not endear him to the Hadens. That year, Whistler had his first two etchings accepted at the Royal Academy.

Whistler was wrong about London: the art scene there was less lively and revolutionary than in Paris. By the time Whistler settled in London, the great days of the Pre-Raphaelite Brotherhood were over. The group had been viewed as the English counterpart of the French Realist movement, and its works had received praise from Baudelaire when they were shown at the Paris World Fair in 1855. The Pre-Raphaelite Brotherhood championed faithfulness to nature, a return to the purity and spirituality of Italian painting before what they saw as the decadence born from Raphael's idealism, a departure from the excesses of academic style, and the spreading of an artistic culture among the working classes. The controversy which surrounded the first appearance of their work, their antiacademic stance, and their search for spirituality would have been sufficient to attract Whistler's attention.

When Whistler went to the Royal Academy exhibition together with Fantin-Latour, to admire John Everett Millais's new work, Millais told him how much he liked his etchings, just as was later to praise *At the Piano* when it was shown at the 1860 Royal Academy exhibition. Was London going to be a success for Whistler? The painting which had been rejected in Paris was given a warm reception in London. Everyone admired it and the painter John Philip, a friend of Millais's bought it for thirty pounds. Deborah Haden was delighted that her brother had at last taken her advice, and the young American who had been denied recognition in Paris was becoming a highly regarded painter in England.

Whistler continued to do a lot of etchings, some of which were exhibited in Paris in 1862, but they were not published as a set before 1871, as a series of clear and firm depictions of the Thames entitled *Sixteen Etchings of Scenes on the Thames and Other Subjects* the so-called *Thames Set*.

Started in 1860, *Wapping on Thames* (see p. 17),* in which Whistler's new model and mistress, Joanna Heffernan, a red-haired Irish beauty, makes her first appearance, reveals a sense of

* Wapping and Rotherhithe were a maze of narrow streets along the Thames and were considered among the most squalid areas in London.

atmosphere and light that is not far removed from Monet's and Frédéric Bazille's ideas of the same period: combining Realism with the immediacy of «plein-air» painting. Figures are seated in the foreground, a conspicuous post supports the balcony roof, and the background is a view of shipping on the Thames.

In September 1861, Whistler left for France and in November he moved back to Paris with Jo, settling in the Boulevard des Batignolles, where he painted her as the subject for his *Symphony in White No. 1: The White Girl* (see p. 31). The picture shows the young woman, standing on a wolfskin rug and wearing a white dress, against a white background. The flower she bears in her hand relates the picture to Rossetti and the Pre-Raphaelite movement, and the restrained opulence of the painting reflects Whistler's admiration for Velázquez and the Spanish masters of the Golden Age. In his catalogue, David Park Curry compares *Symphony in White No. 1* to Antoine Watteau's *Gilles*:

> The single most striking parallel between the two paintings in their almost identical visual impact: each artist created a curiously lonely figure, somewhat flattened and unconfortably silhouetted against its background. Each artist staged a *tour de force* that captured the nuances of light playing over a model clad in white.*

Yet this painting, which is a touchstone for Whistler's own ideas on aesthetics, was rejected by the Royal Academy for its exhibition in 1862.

* David Park Curry. *James McNeill Whistler at the Freer Gallery of Art*. New York, London: W. W. Norton and Co., 1984, p. 38.

« The Adam and Eve », Old Chelsea, 1879
Etching and drypoint on japanese paper, II/II, 6⅞" × 11⅞" (17.3 × 30.2 cm)
Art Gallery of Ontario, Toronto. Gift of Inco Limited

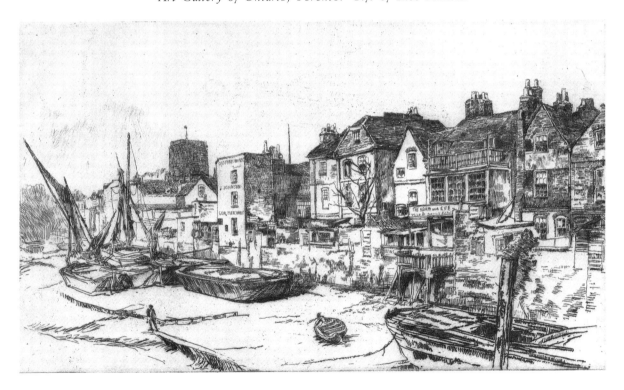

Whistler and Jo decided that they wanted to go to Spain and stopped on the way on the southwestern coast of France in the Basque country. Whistler painted a number of powerful seascapes there. However, in a letter to Fantin-Latour, he wrote:

> I admit you are right. «Plein-air» painting should be done at home.... The thing is there for a moment, then it is gone forever. You strike a pure clear note and catch a color in midflight the way you would shoot a bird. And the public demands a polished picture.

Ever a nomad, Whistler moved in March 1863 to a house in Chelsea, at 7 Lindsey Row, near the old Battersea Bridge. In April he traveled to Holland with Legros to study Rembrandt's etchings. His own etchings won him a gold medal at an exhibition in The Hague. During that journey he stopped off in Paris to see his friends, but he was very much a Londoner now. He was close to the Pre-Raphaelites, Rossetti, Burne-Jones, William Morris, and the poet Swinburne, whom he introduced to Manet. Whistler was a conspicuous figure in clubs and drawing rooms, cultivated the ladies, and became the envy of other socialites by collecting Chinese porcelain and Japanese prints, which he was instrumental in bringing into fashion in London. He also started to acquire a name for himself by his extravagance of dress, his verbal sallies and practical jokes, and his eclectic taste.

A SCANDAL, THEN FAME

The White Girl was rejected by the Salon of 1863, as was Manet's *Picnic*. This was not the first time that the jury's decision had reflected such hostility toward avant-garde painting, but that year an exceptionally large number of pictures were left out of the exhibition and the artists were furious. The uproar was such that Napoleon III, «wishing to allow the public to judge the legitimacy of these complaints,» decided that the rejected entries should be exhibited separately. Seven hundred and eighty-one canvases were shown at the Salon des Refusés, including works by Fantin-Latour, Bracquemond, Henri Harpignies, Johan Barthold Jongkind, Camille Pissarro, Legros, Manet, and Whistler. Among the artists not mentioned in the catalogue was an unknown painter, Paul Cézanne!

Manet and Whistler were singled out for derision by the public. The reasons given were the same in both cases: their paintings were slapdash, the subject matter «vulgar,» the draftsmanship mediocre. As the public saw it, there was no attempt to maintain the hierarchy of planes, and color had been used to emphasize volumes rather than model the figures.

The White Lady (as it was called in the catalogue) which was particularly badly received, was deliberately hung near one of the entrances so as to make it impossible to miss. In his book, «L'Œuvre,» Emile Zola tells how before this «very curious vision seen through the eye of a great artist, people were nudging each other, doubling up with laughter, and there was always a group standing about with open-mouthed hilarity.» Together with *The Picnic*, Whistler's entry was the greatest joke at the exhibition, and it was greeted with disgust and horror by many. One exception, according to a letter Fantin-Latour wrote to Whistler in Amsterdam at the time, was Baudelaire:

> We find the whites excellent; they are superb, and at a distance (that's the real test) they look first class. Courbet calls your picture an apparition.... Baudelaire finds it charming, exquisite, absolutely delicate. Legros, Manet, Bracquemond, De Balleroy, and myself, we all think it admirable. *

* Quoted in Andrew McLaren Young et al. *The Painting of James McNeill Whistler.* New Haven, London: Yale University Press, 1980, I, pp. 17-20. Trans. by David Curry, op. cit.

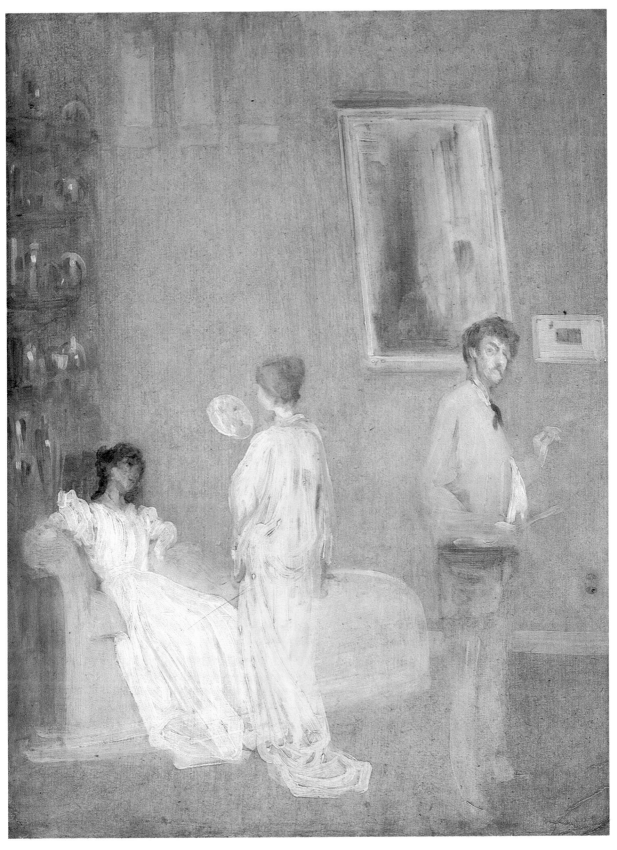

THE ARTIST IN HIS STUDIO, c. 1864. Oil on panel, 24¾″ × 18¾″ (62.5 × 47.4 cm)
The Art Institute of Chicago. Friends of American Art Collection

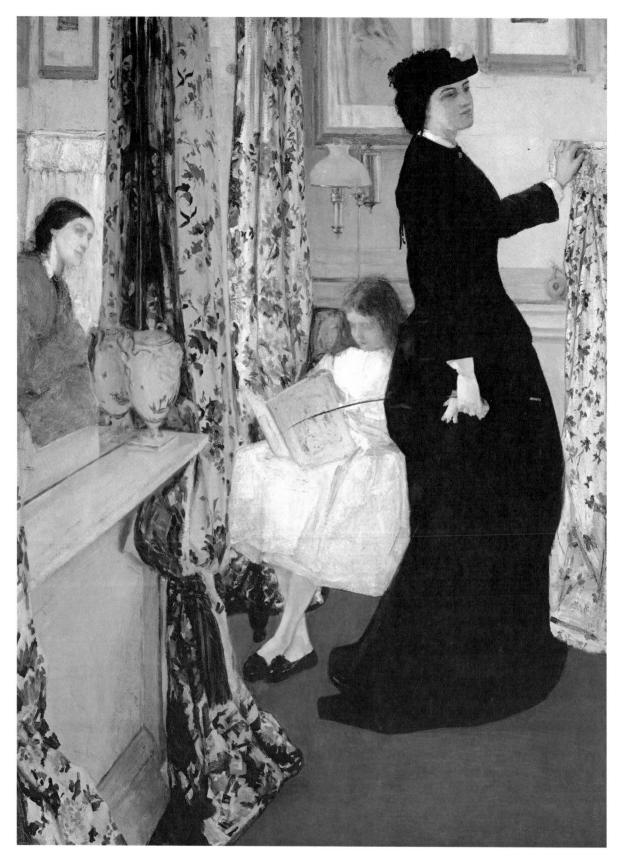

30

HARMONY IN GREEN
AND ROSE:
THE MUSIC ROOM, 1860-61
Oil on canvas, 37⅝″ × 27⅞″
(95.5 × 70.8 cm)
The Freer Gallery of Art
Smithsonian Institution
Washington, D.C.
◁

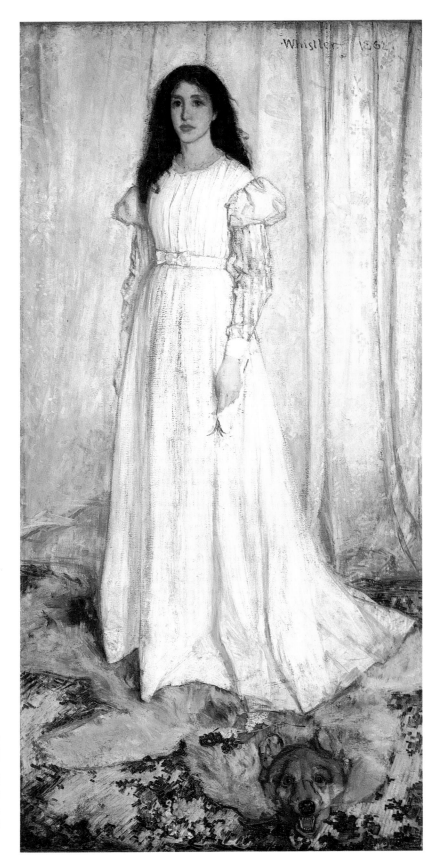

THE WHITE GIRL:
SYMPHONY IN WHITE
No. I, 1862
Oil on canvas, 84¼″ × 42½″
(214.7 × 108 cm)
National Gallery of Art
Washington, D.C.
Harris Whittemore Collection

CAPRICE NO. 2 IN PURPLE AND GOLD:
THE GOLDEN SCREEN, 1864
Oil on wood panel, 19¾″ × 27″
(50.2 × 68.7 cm)
The Freer Gallery of Art
Smithsonian Institution, Washington, D.C.

ROSE AND SILVER: THE PRINCESS
FROM THE LAND OF PORCELAIN, 1863-64
Oil on canvas, 78¾″ × 45¾″
(199.9 × 116.1 cm)
The Freer Gallery of Art
Smithsonian Institution, Washington, D.C.

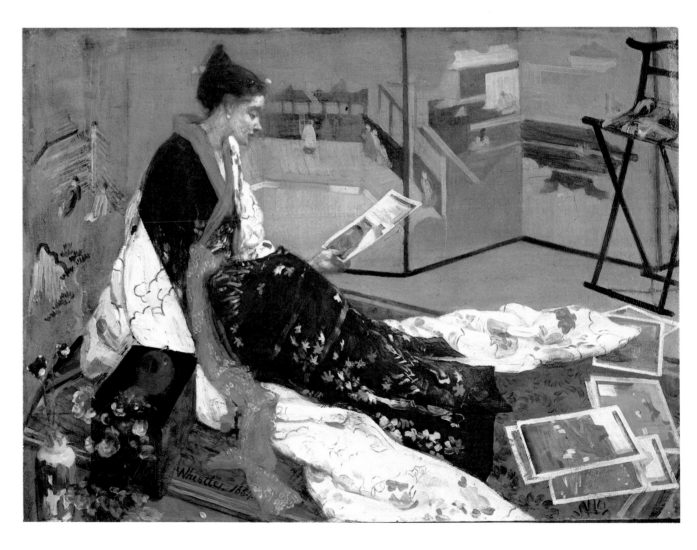

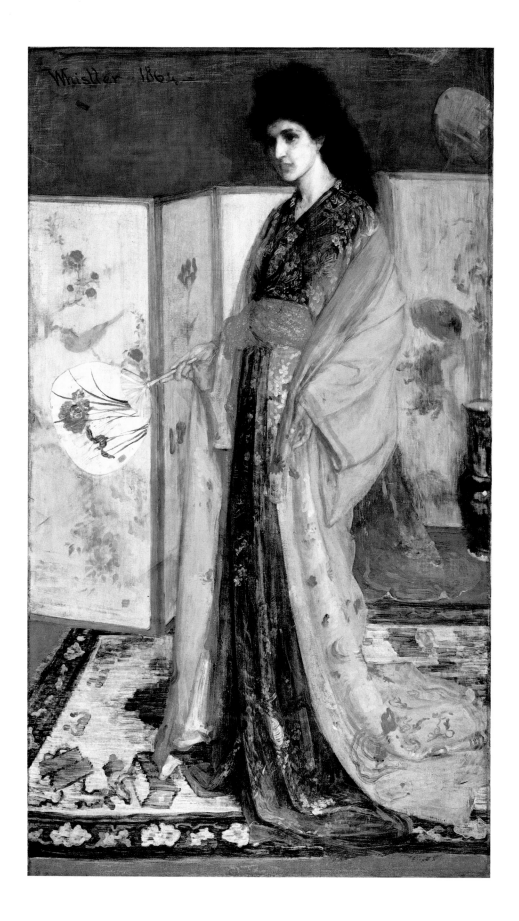

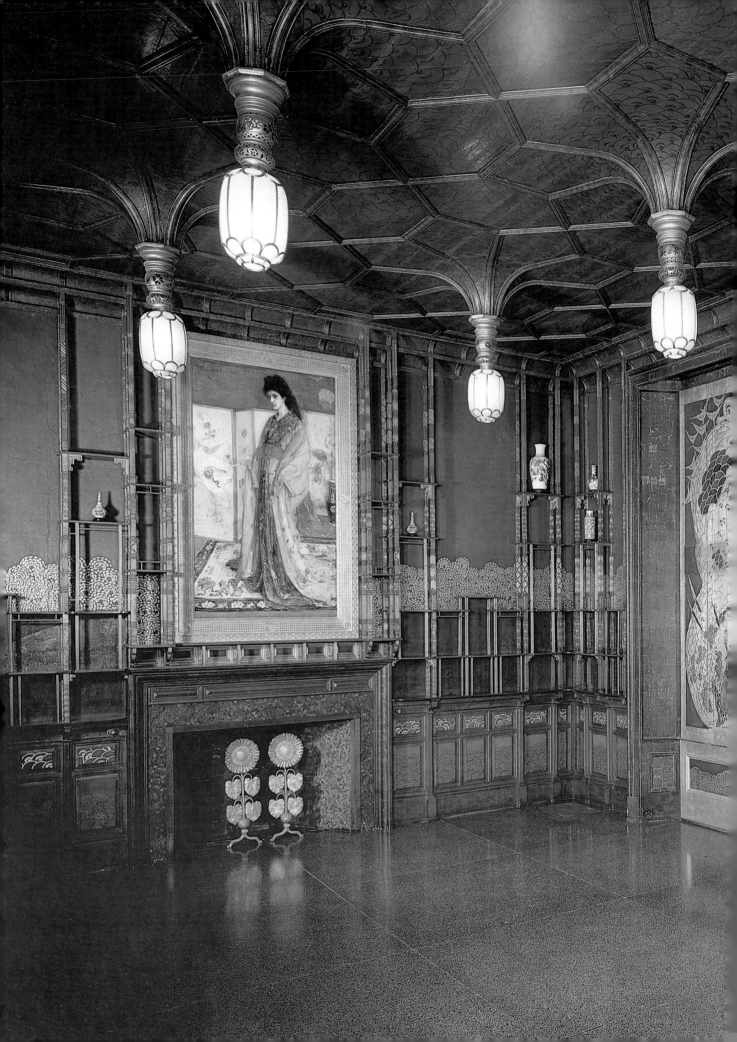

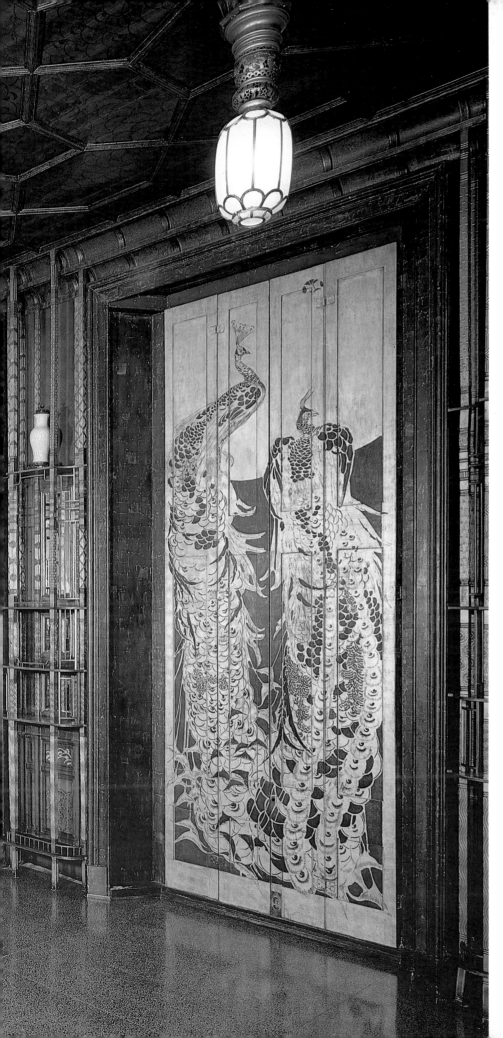

THE PEACOCK ROOM:
HARMONY IN BLUE
AN GOLD
(NORTH-EAST CORNER)
1876-77
Oil color and gold
on leather and wood
13′9⅞″ × 33′2″ × 19′11½″
(4.258 × 10.109 × 6.083 m)
The Freer Gallery
of Art
Smithsonian Institution
Washington, D.C.

35

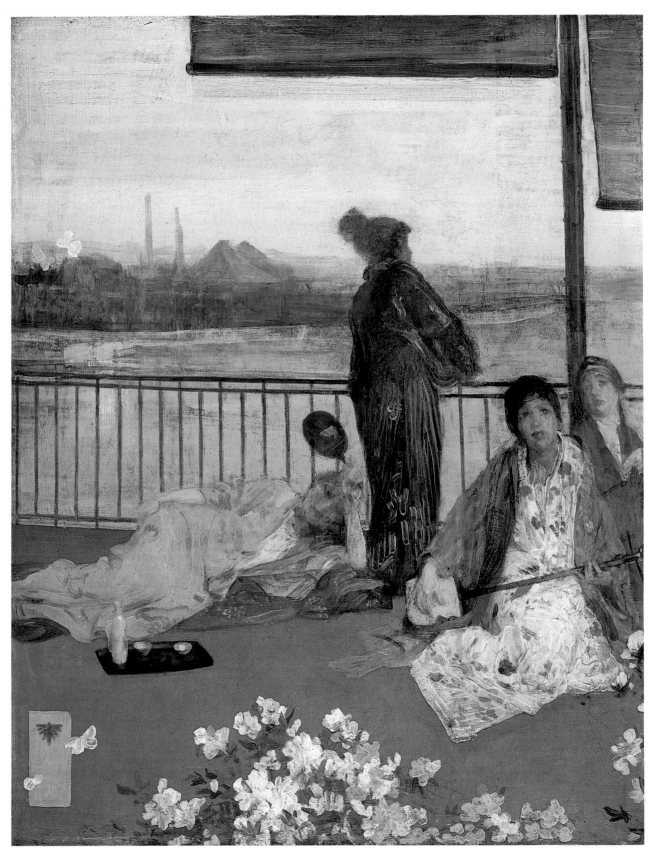

VARIATIONS IN FLESH COLOR AND GREEN: THE BALCONY, 1864
Oil on wood panel, 24¼″ × 14¼″ (61.4 × 48.8 cm)
The Freer Gallery of Art, Smithsonian Institution, Washington, D.C.

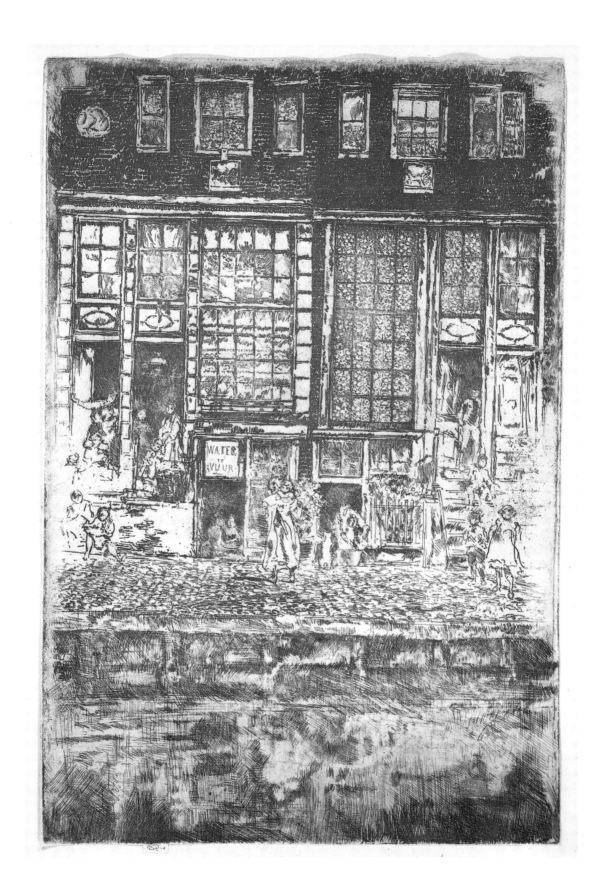

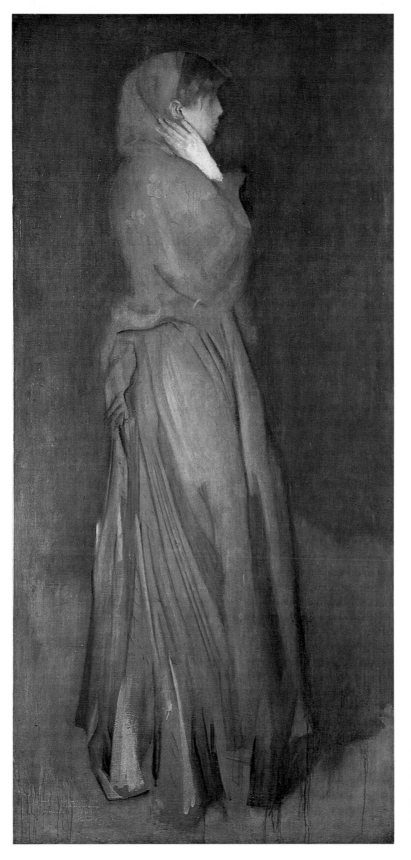

ARRANGEMENT IN GRAY
AND BLACK NO. 2:
THOMAS CARLYLE, 1872-73
Oil on canvas, 67¼″ × 56½″
(171.1 × 143.5 cm)
Glasgow Art Gallery and Museum
▷

ARRANGEMENT IN YELLOW
AND GRAY:
EFFIE DEAN, 1876
Oil on canvas, 76¼″ × 36½″
(194 × 93 cm)
Rijksmuseum, Amsterdam

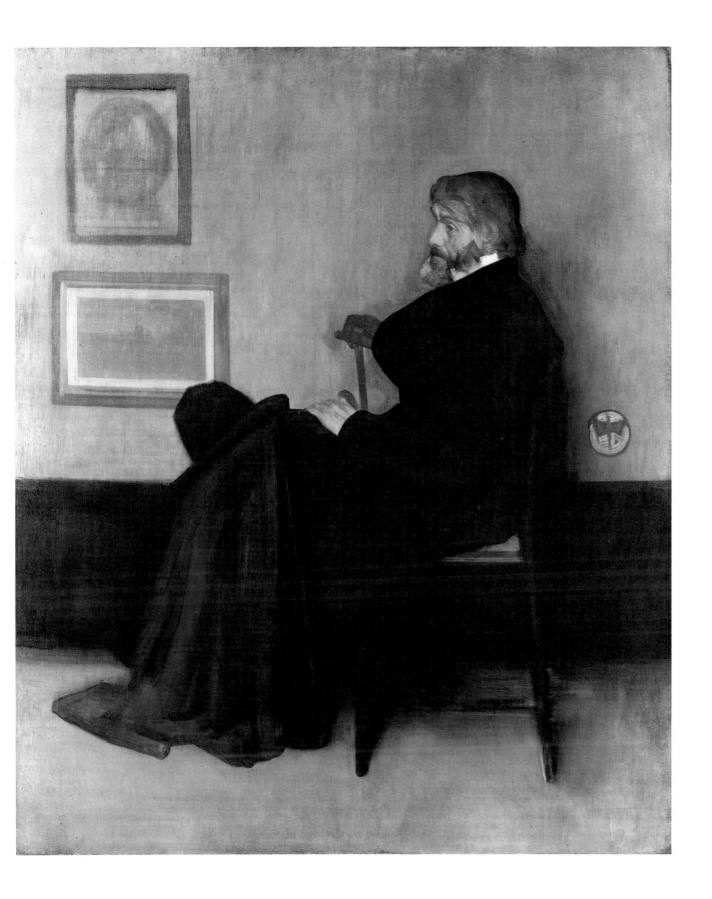

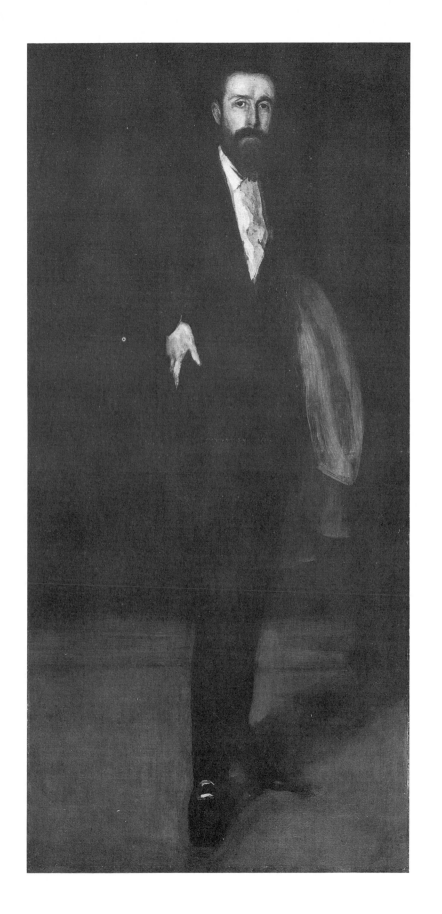

Arrangement in Black
Portrait of F. R. Leyland
1870-73
Oil on canvas, 75⅞" × 36⅛"
(192.8 × 91.9 cm)
The Freer Gallery of Art
Smithsonian Institution
Washington, D.C.

BREAKFAST IN THE GARDENS, c. 1880
Watercolor on paper, 5″ × 8½″ (12.7 × 21.9 cm)
The Freer Gallery of Art, Smithsonian Institution, Washington, D.C.

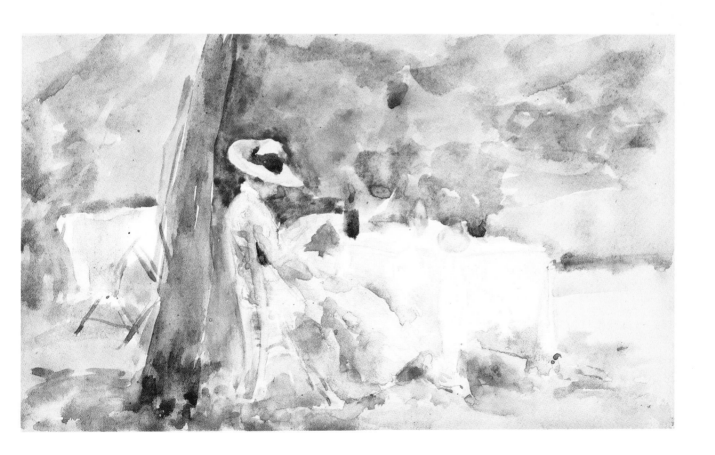

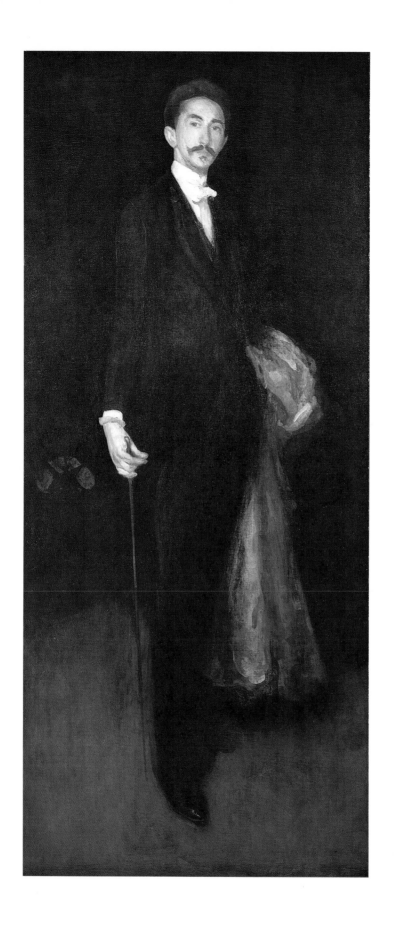

ROBERT, COMTE DE
MONTESQUIOU-FEZENSAC, 1891-92
Oil on canvas, 82⅛″ × 36⅛″
(208.6 × 91.88 cm)
The Frick Collection, New York

HARMONY IN RED:
LAMPLIGHT, c. 1884-86
Oil on canvas, 76¾″ × 35⅜″
(190.5 × 89.7 cm)
Hunterian Art Gallery
University of Glasgow
Birnie Philip Gift

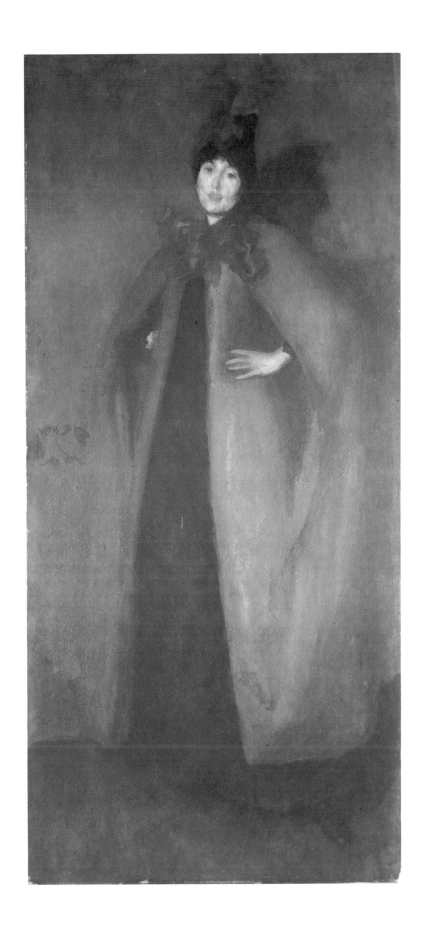

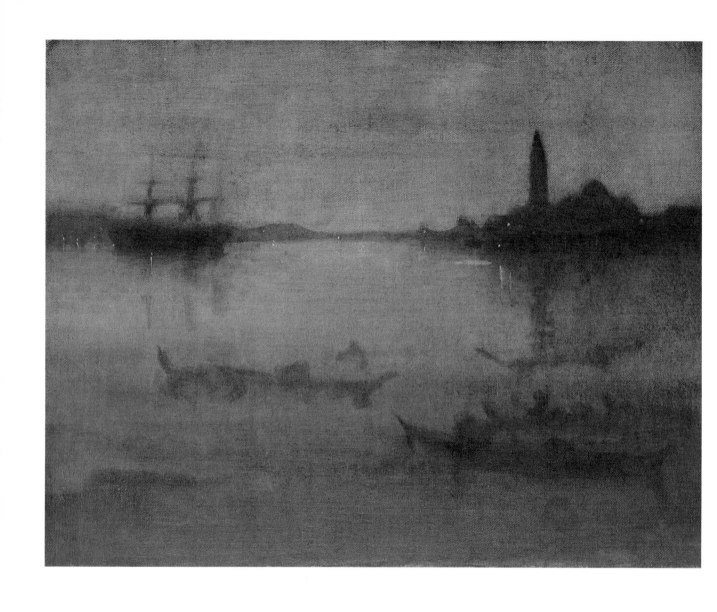

THE LAGOON, VENICE: NOCTURNE IN BLUE AND GOLD, 1879-80
Oil on canvas, 20″ × 25¾″ (50.8 × 65.4 cm)
Museum of Fine Arts, Boston. Emily L. Ainsley Fund

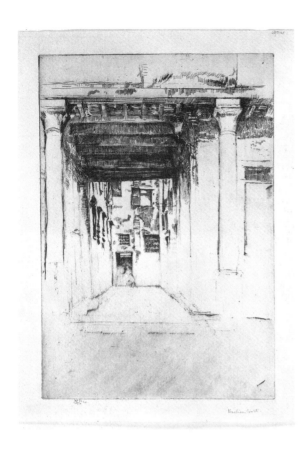

Venetian Court, 1879
Drypoint, II/III, 11½″ × 7⅞″ (29.1 × 20 cm)
The Freer Gallery of Art
Smithsonian Institution, Washington, D.C.

Garden, 1880
Etching and drypoint, IV/VIII
12″ × 9¼″ (30 × 23.8 cm)
The Metropolitan Museum of Art, New York
The Harris Brisbane Dick Fund

sets of etchings were sold. However, Millais wrote to Whistler to compliment him on the quality of his Venice works. At the time of the second exhibition, Pissarro wrote in a letter to his son Lucien that he greatly regretted not having seen it, and he recommended that Lucien study Whistler's prints. The etchings were published three years later, in 1886, in a set of twenty-six works, together with a sheet of «Propositions,» which stated Whistler's principles on such matters as size of plates, width of margins, and heavy linework. Now that it is possible to clear away some of the extravagance of personality which dominated contemporaries' view of the painter, we discover that he was a remarkable engraver. He was one of the first to work copper directly from nature, and his landscapes, particularly of Venice, have an admirable clarity and firmness. The artist's vision was captivated less by the theme, the landscape, than by tone values and sonorities suggesting the essentials of the scene in a few strokes, or hatchings, sometimes incorporating brilliantly inventive flourishes, refusing the merely picturesque. These views, in which Venice was more imagined than analyzed, though seen with an astonishingly perceptive eye, were not understood. They were considered unfinished. They show also a painter's eye, which uses black and gray, particularly in the second set, to add a vaporous softened quality to the shimmering forms, thereby introducing an element of aerial perspective in which space seems to be suspended in the half-light between sky and water. As Lochnan pointed out, Whistler must have been thinking of William Turner, whose work he greatly admired:

Two Doorways, 1880
Etching and drypoint, VI/VI, 8" × 11½" (20 × 29.1 cm)
National Gallery of Art, Washington, D.C. Rosenwald Collection

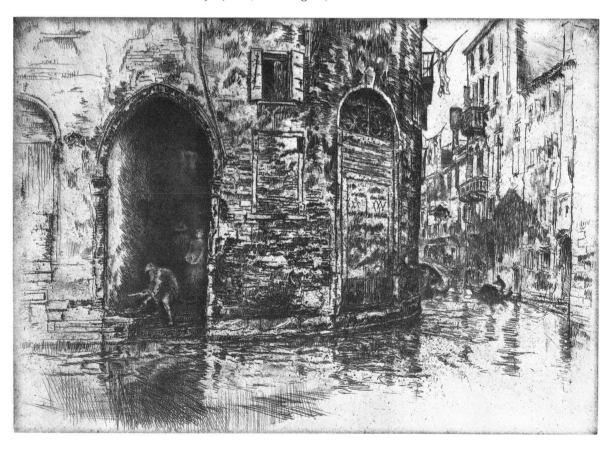

The fluid way in which Whistler applied plate tone to give his etched nocturnes translucency recalls Turner's magnificent watercolor «notes» of Venice. . . . What Turner said with watercolor, Whistler said with etching; Venice was never more poetically portrayed. *

Whistler's is not an art of broad daylight. At a time when the Impressionists were recording dazzling sunlight, he opted for shadows, dusk, and nighttime, though he shared their attachment to fleeting effects that signify the irretrievable moments of life. His approach is to bite the metal lightly, proceeding by suggestions rather than blatant emphasis. In his etchings, just as in his paintings, the overwhelming impression is one of repose, in which subtle gradations of tone are expressed with the utmost economy and the scene implies intimacy or silence. He treats his sitters with extraordinary delicacy and shows a similar restraint and fervent observation in his landscapes. Whether he is using the etcher's needle or the paintbrush, he preserves a constant lightness of touch, starting from the surface of things to yield their inner essence. Of his etchings, Lucien Pissarro wrote to his father, «He does wonderful things with a few lines.» Pissarro wrote back:

> The suppleness you find in them, the pithiness and delicacy which charm you derive from the inking which is done by Whistler himself; no professional printer could substitute for him, for inking is an art in itself and completes the etched line. **

This was the tribute of one craftsman to another, though it did not prevent him from also saying that Whistler could be a bit of a fraud at times.

This artistic subtlety is in stark contrast to Whistler's character in life, which became even wittier, sharper, and more unpredictable after the trial. Unfortunately he had the worst friends that could be wished on him at the time—his entourage included Oscar Wilde, whose own extravagant and exhibitionist behavior encouraged worse from him, not to speak of the accusations of immorality that the friendship provoked in others. Wilde was to appoint himself as Whistler's impresario. He praised his work in a series of lectures given in the United States.

Luckily a distraction presented itself in the form of Valerie, Lady Meux, the wife of a rich brewer, very much a member of the fashionable circles of the time, who commissioned a portrait. He painted three portraits of her between 1881 and 1886; *** they do not have the distinction of earlier portraits, although the first, exhibited at the Salon of 1882, impressed Degas, who found it «very striking, and refined to the point of excess, but what spirit!» As so often happened with him, Whistler managed to offend his model, and the third portrait remained unfinished.

Whistler returned to favor with the public, and dashed off one portrait after another, commissioned or otherwise. They are perceptive, sophisticated, and subtle portraits, often painted with a quick brush, with constant expriments of composition and colors. Some reach to the limit of visual pyrotechnics, such as *Arrangement in Flesh Color and Black: Portrait of Théodore Duret* (see p. 67), which shows the critic in black evening dress with a pink domino cape against his arm and holding a fan. These accessories caused a stir at the time, but the picture is above all a set of successful color contrasts, in spite of the severity of the jacket and the plain background.

* Katharine Lochnan, op. cit., p. 208.
** John Rewald. *Camille Pissarro: Letters to His Son Lucien*. London, 1943. Letter of February 28, 1883, pp. 22-3.
*** *Arrangement in Black, Lady Meux*, 1881-82 (Honolulu Academy of Arts, Hawaii), *Harmony in Rose and Gray: Portrait of Lady Meux* (see p. 66), *Portrait of Lady Meux with her Furs*, 1881-86 (no longer extant).

*The Village
Sweet-Shop
1884-86
Etching, I/I
3¼" × 4⅞"
(8.3 × 12.4 cm)
The Freer Gallery
of Art
Smithsonian
Institution
Washington, D.C.*

In 1886 Whistler held his second one-man show, entitled «Notes, Harmonies, Nocturnes.» In 1887 he printed a handful of impressions of the London etchings. He also made a number of etchings to mark Queen Victoria's Golden Jubilee, including twelve small plates, most of them of a moving boat, produced while attending the Naval Review in his official capacity as president of the Society of British Artists. In the fall of that year he made another visit to Holland and Belgium, etching nineteen plates, including thirteen of Brussels.

> As in Venice, he set out to distill the essence of form dissolved in light. . . .
> By drawing only «the bones, the skeleton, of the architecture,» the buildings
> were reduced to linear essentials. The insubstantial and delicate images
> hang like cobwebs in the air, with no real solidity. *

There followed a whole succession of exhibitions in London, Paris, Brussels, and Edinburgh, awards, sales, negotiations, and discussions in fashionable circles. The master began to have disciples, one of them Walter Sickert. Mrs. Cassatt, the sister-in-law of the Impressionist painter (who said, «It is a good thing we have a Whistler in the family»), commissioned a portrait, *Arrangement in Black No. 8* (Mrs. John B. Thayer Collection, Rosemont, Pennsylvania). But ever since his trial, he had been busy trying to confound his detractors and assert the right of any artist to paint as he feels. On February 20, 1885, Whistler gave a lecture entitled «The Ten O'Clock» (that was the time at which it was given) at Princess Hall, but it did not convince his audience, and one or two remarks on the behavior of writers provoked Oscar Wilde's wrath and attracted Swinburne's spite. Three years later Mallarmé, who had probably met Whistler at Manet's studio as a result of an introduction by Duret (unless it was Monet who introduced them over a formal lunch in Paris), agreed to translate the paper into French. Mallarmé, a Symbolist poet who at the time was teaching English at the lycée Janson-de-Sailly in Paris, was the mentor of some of the best Modernist writers. The Tuesday gatherings at his apartment on the Rue de Rome were famous, and a number of habitués of his salon appear in the pages of Edmund Wilson's «Axel's Castle.»

* Katharine Lochnan, op. cit., p. 241.

WHISTLERISM. COMES INTO ITS OWN

> When we were young, Whistlerism and Mallarméism were labels that
> caught our fancy as preciosities worthy of us superior beings, and were
> also neologisms which made an impression on the public. *

Blanche called on Whistler in London in 1885. He later wrote an account of Whistler's apartment, the apartment of an aesthete; of the man himself, whom he did not like; and of the paintings, particularly the portraits, about which he wrote that Whistler «did not *finish* more than a dozen or so in his life.» Then there were the sketches,

> in which wan little figures in the Japanese girl mold, both affected and
> hieratic [words in vogue at the time], wave fans and parasols against
> sickly turquoise skies. **

This savage attack goes on for several pages. Only the portraits of Lady Meux find favor with Blanche, who, praising them, confessed, that never had he had such a revelation of a new art.

* Jacques-Emile Blanche, op. cit.
** Ibid.

The Mill, 1889. Etching, I/V, 6⁵/₁₆" × 9¹/₂" (16 × 24 cm)
The Freer Gallery of Art, Smithsonian Institution, Washington, D.C.

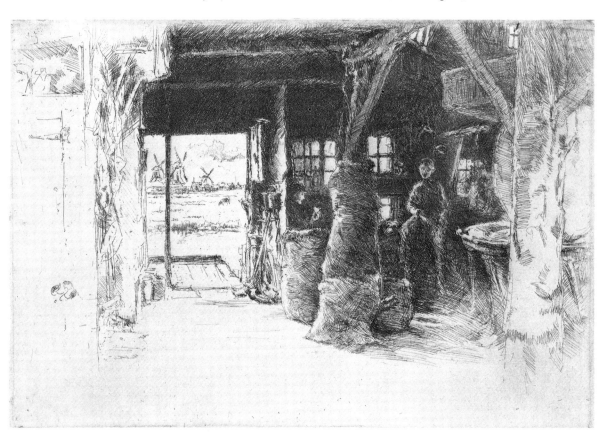

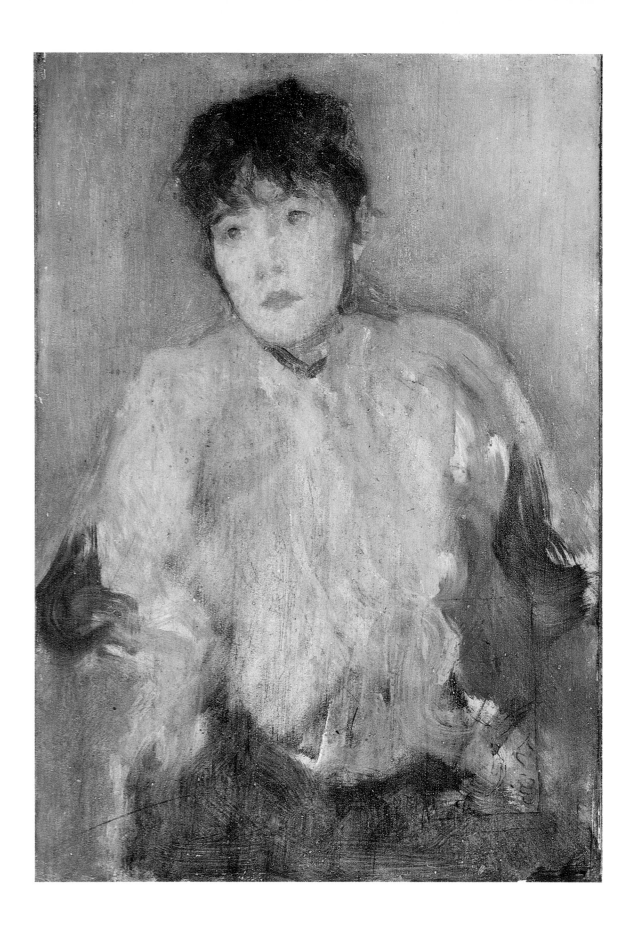

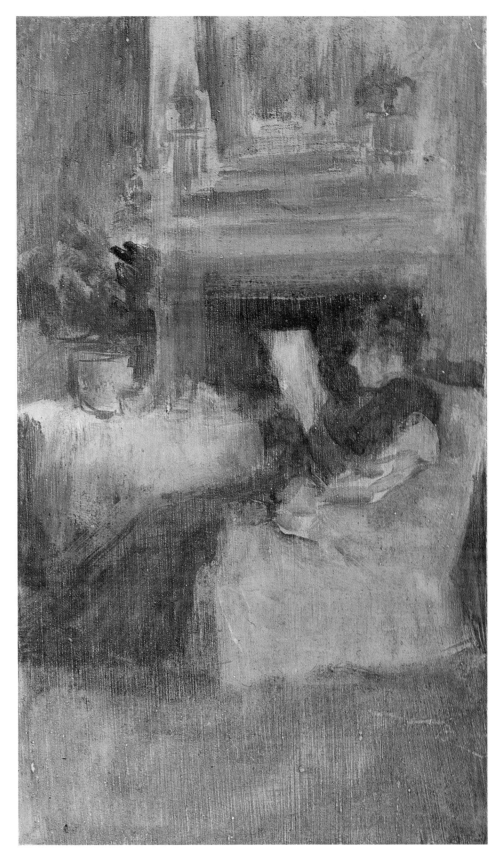

THE ROSE SCARF
c. 1890
Oil on panel
10¹⁄₈″ × 7″
(25.8 × 18 cm)
Hunterian Art Gallery
University of
Glasgow
Birnie Philip Goft
◁

MISS ETHEL PHILIP
(MRS. CHARLES
WHIBLEY)
READING, 1894
Oil on wood
8³⁄₈″ × 5″
(21.2 × 12.7 cm)
Hunterian Art Gallery
University of
Glasgow
Birnie Philip Gift

THE DANCER:
GREEN AND BLUE, c. 1890
Watercolor with blue background
10½" × 6¾"
(26.6 × 17.2 cm)
Private Collection, U.S.A.
▷

The Winged Hat, 1890
Lithograph, 7" × 6¾" (17.8 × 17 cm)
The Metropolitan Museum of Art, New York
The Harris Brisbane Dick Fund

The Sisters, 1894
Lithograph, II/II, 5¹⁵/₁₆" × 9¹/₁₆" (15 × 23 cm)
The Freer Gallery of Art, Smithsonian Institution
Washington, D.C.

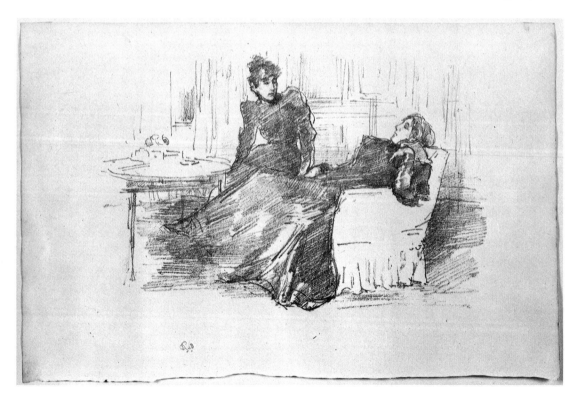

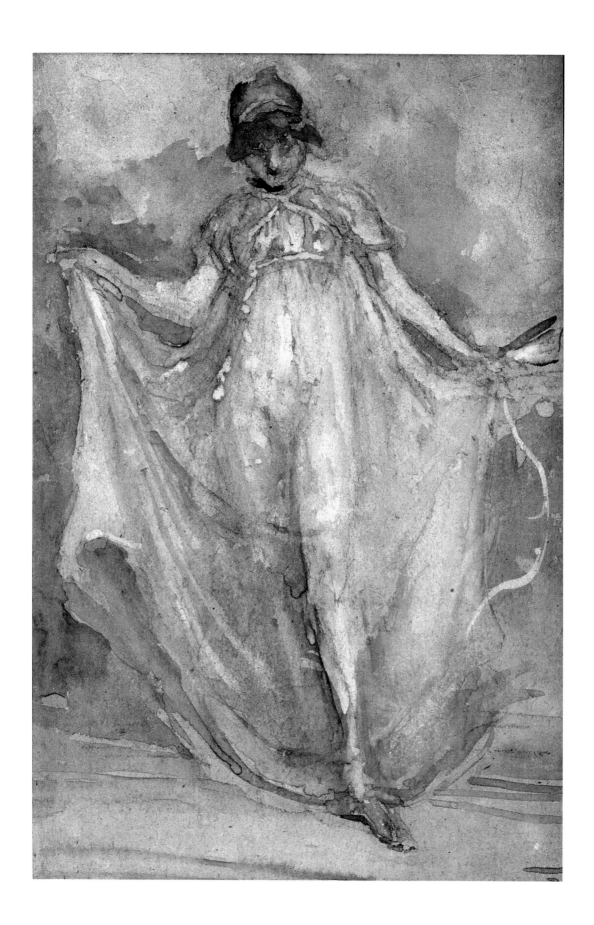

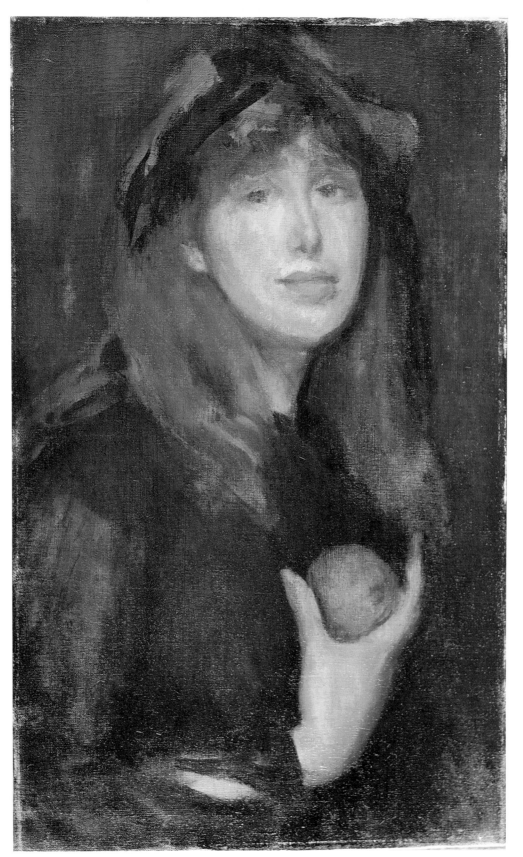

DOROTHY SETON
A DAUGHTER OF EVE
1903
Oil on canvas
19⅞″ × 12½″
(51.7 × 31.8 cm)
Hunterian Art Gallery
University of Glasgow
Birnie Philip Gift

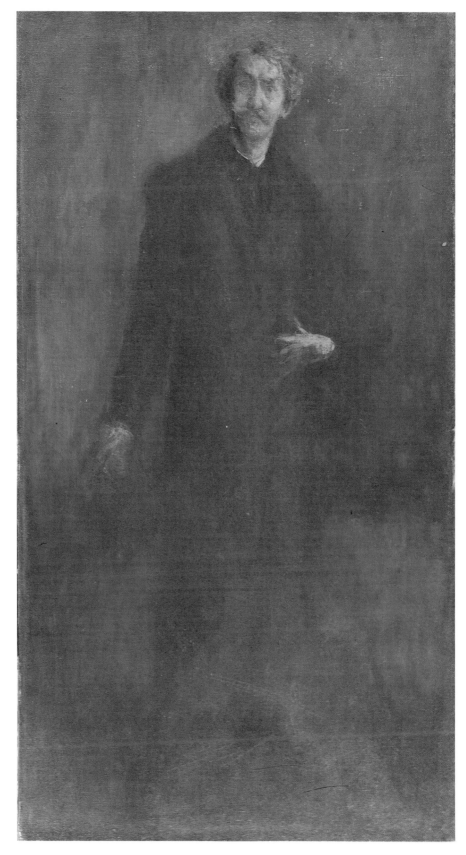

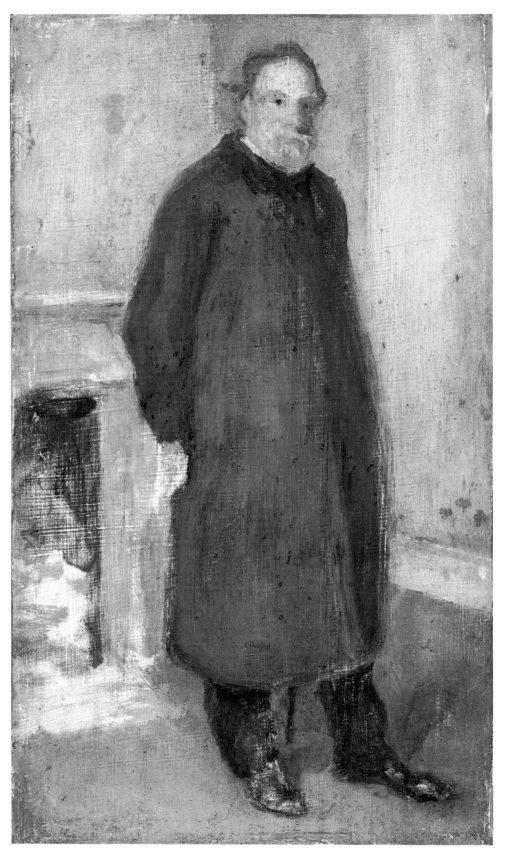

ROSE AND BROWN:
THE PHILOSOPHER
(EDWARD HALLOWAY)
c. 1896-97
Oil on wood panel
$8\frac{3}{8}'' \times 5\frac{1}{4}''$
(21.5 × 13.5 cm)
Private Collection
Paris

A warm friendship developed between Whistler and Mallarmé, the poet famed for his predilection for the rare and recondite. His translation of the « Ten O'Clock » lecture appeared first in the « Revue Indépendante » in May 1888 and later in a pamphlet which Mallarmé dedicated « to Degas, charming enemy and best of friends. » It was read aloud at Berthe Morisot's salon. The critics seized upon it, especially Huysmans, who enthused over the *Nocturnes* exhibited at the Durand-Ruel gallery: « Veiled horizons half seen in another world . . . a spectacle of blurred nature or of floating cities . . . bathed in the uncertain light of a dream. » He also praised Whistler for having « aristocratically practiced an art impenetrable to the received ideas and aloof from the common herd, an art withdrawn in splendid isolation and proud reserve. » The « Ten O'Clock de M. Whistler » was a constant subject of discussion and controversy in salons, cafés, and studios, and above all at the Tuesday gatherings held at Mallarmé's apartment. It is true that Whistlerism and Mallarméism, whether they were seductive poisons, exotic opiates, or overelaborate artworks, caused excitement, annoyance, or outright rebellion in the years of Symbolism.

In 1888, Whistler suddenly broke off with Maud Franklin (thereby creating further trouble for himself), and in August he married Beatrix

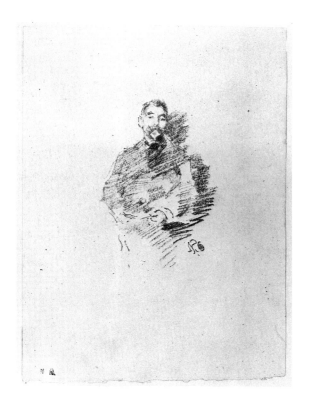

Portrait of Mallarmé, 1892
Lithograph, 3⅞" × 2¾" (9.9 × 7 cm)
National Gallery of Art, Washington, D.C.
Rosenwald Collection

Godwin, the wealthy widow of his friend E. W. Godwin, the architect. After the honeymoon, they moved to 110 Rue du Bac, and he took up a studio in the Rue Notre-Dame-des-Champs. He was awarded the Legion of Honor. He became in Paris, as he had previously been in London, a rallying point for the aesthetes and snobs of the day.

In August 1889 he traveled to Amsterdam, making a series of ten etchings which are characterized by two-dimensional patterns in asymmetrical arrangements as well as extraordinary chiaroscuro effects showing the tendency toward abstraction already noticeable in some of his Brussels etchings.

In 1891, after organized lobbying by Mallarmé and the influential critics Duret, Gustave Geffroy, and Roger Marx, the *Portrait of the Painter's Mother* was purchased for the Musée du Luxembourg. A number of well-known contemporaries regarded it as one of the masterpieces of the century. This token of official recognition had a welcome effect on Whistler's reputation in both Britain and the United States. Shortly before, the Corporation of Glasgow had acquired his *Portrait of Thomas Carlyle*. His retrospective exhibition of forty-three « Nocturnes, Marines and Chevalet Pieces, » held at the Goupil Gallery in London in March 1892, was highly successful.

When he was not writing a malicious lampoon or giving a sensational interview, living down spiteful gossip about his break with Maud Franklin and his marriage, or entertaining, perorating, or publishing a miscellany of pieces including a selection of his correspondence (« The Gentle Art of

Making Enemies») — he had already published in 1878 an account of the Ruskin libel suit (which delighted Mallarmé) under the title «Whistler v. Ruskin: Art and Art Critics» — Whistler occasionally found time to organize an exhibition, work on prints, and paint. He produced a beautiful series of twenty-three etched views of Paris in which he developed even further his technique of painterly effects of dark shadows and vibrant light. He also produced many lithographs, mostly in an intimist style reflecting his happy domestic life.

Montesquiou was among his fashionable friends and admirers, praising his talents to the skies on both sides of the Channel, and Whistler painted his portrait, *Arrangement in Black and Gold* (see p. 70). Unfortunately, it is too conventional a painting, a tame portrait which does nothing to suggest the flamboyant and effete staginess of the man. (However, Montesquiou left a hilarious account of the portrait sittings which has the two narcissistic creatures sitting face to face and one saying to the other, «Look at me another moment and you will look at yourself forever!») By contrast the small lithograph portrait of Mallarmé is astonishingly true to life (see p. 85). Produced in 1893 in the Rue du Bac studio, after a few preliminary studies, it appeared as a frontispiece to «Vers et Prose.» As Duret wrote later, «The Mallarmé is exstraordinarily lifelike. . . . Anyone who knew him can almost hear him speak.» The poet himself was delighted with it.

Mr. and Mrs. Whistler went on a tour of Brittany. When they returned to Paris they entertained on a large scale (their Sunday brunches were famous). At these gatherings Whistler would always be conspicuous, dressed in extravagant outfits with outrageous neckties. The walls would be painted yellow, and there would always be a profusion of baubles to gaze at, including his precious blue and white porcelain. These were the decadent Nineties, with the superficial Symbolism of Huysmans and Jean Lorrain. Yet Whistler's real aspirations were elsewhere. He dreamed to escape from what he considered to be the vulgarity and banality of the world he lived in. The setting of his life, his poseur's existence, acted as a kind of smokescreen. His artificial entourage

Pantheon, Luxembourg Gardens, 1892-93
Etching, I/I, 3¼" × 7⅞" (8.2 × 20 cm)
The Freer Gallery of Art, Smithsonian Institution, Washington, D.C.

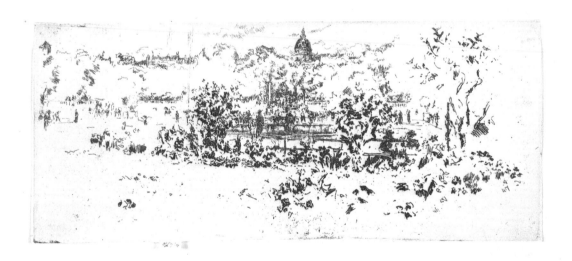

« *La Fruitière de la Rue de Grenelle* »
(*The Fruit-Vendor of the Rue de Grenelle*), 1894
Lithograph, 9" × 6⅛"
(22.7 × 15.5 cm)
The Metropolitan Museum of Art
New York
The Harris Brisbane Dick Fund

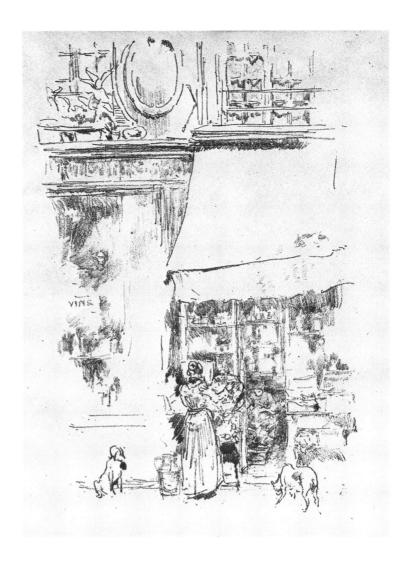

of snobs and flatterers was only a puppet theater under his disillusioned eye. One person who understood Whistler was Mallarmé. He recognized the depth in the personality of this aesthete, this aggressive society man with a sensuous temperament. Whistler appreciated Mallarmé's taste for nocturnes, for mystery and silence, and he sensed that Mallarmé was a self-protected but painfully sensitive man — a poet of the dreamy suggestion, for whom art had an evocative power beyond the everyday significance of things. Their friendship, which lasted until Mallarmé's death, is attested to by a moving exchange of correspondence.

What Whistler perhaps lacked was stronger creative impulse and the belief in the discipline required to go beyond the initial impression made by the shifting scene when contours fade and night begins to fall. Perhaps this lack partly explains the frustration that came through in his recurrent bouts of bad temper. He gave himself up to the pleasure of the moment and was oblivious to the passing of time. As Proust was to write of Elstir, « His efforts had gone toward dissolving that collocation of judgments which we call vision, » and this phrase sums up Whistler's approach quite well. It

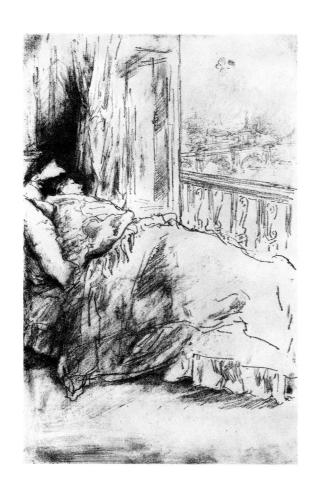

By the Balcony, 1896
Lithograph, 8½" × 5½" (21.6 × 14 cm)
The Freer Gallery of Art
Smithsonian Institution, Washington, D.C.

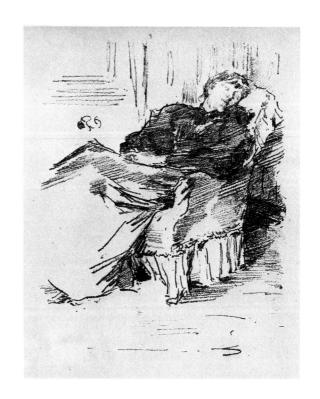

« La Belle Dame Endormie »
(The Beautiful Sleeper), 1896
Lithograph, 7¾" × 6⅛ (19.8 × 15.5 cm)
The Metropolitan Museum of Art, New York
The Harris Brisbane Dick Fund

In his last works, Whistler dwelt on the faded colors of old, dilapidated shopfronts, in paintings like *A Shop in Calais*, of 1896, or *The Laundress, Dieppe*, of 1899, or in hazy landscapes such as *The Dome in the Distance*, painted in Ajaccio in 1901, or *Marseilles Harbor*, also of 1901 (the first three are at the Hunterian Gallery, the last in a private collection in Ludham, Norfolk). The flat colors, tonalities in a minor key so to speak, with their muted effects of old rose and faded green and ocher, recall Vuillard and Bonnard.

Whistler died in London on July 17, 1903, at the height of his fame, which was equal to that of Manet, Degas, or Renoir. Nevertheless, despite some impressive portraits and some sensitive landscapes, his late work had betrayed certain weaknesses. It was as much the prophet of modernity as the arbiter of taste who was acclaimed. This may explain why his direct influence was limited, apart from certain affinities of style among young artists, above all in the English speaking world, and some of his distinctive effects of composition or atmosphere. James McNeill Whistler stands alone, an isolated case. That closes the discussion but it leaves his wider place in history unresolved.

We wish to thank the owners of the pictures reproduced herein, as well as those collectors who did not want their names mentioned.

Musée du Louvre, *Paris* – Rijksmuseum, *Amsterdam* – Barber Institute of Fine Arts, *Birmingham* – *Glasgow* Art Gallery and Museum – Hunterian Art Gallery, *Glasgow* – Isabella Stewart Gardner Museum, *Boston (Mass.)* – Museum of Fine Arts, *Boston (Mass.)* – The Fogg Art Museum, *Cambridge (Mass.)* – The Art Institute of *Chicago* – Hill-Stead Museum, *Farmington (Conn.)* – The *Detroit* Institute of Arts – The University of *Michigan* Museum of Art – The Frick Collection, *New York* – The Metropolitan Museum of Art, *New York* – The *New York* Public Library – Taft Museum, *Cincinnati (Ohio)* – The *Toledo* Museum of Art (Ohio) – The Freer Gallery of Art, *Washington D.C.* – National Gallery of Art, *Washington D.C.* – Art Gallery of Ontario, *Toronto.*

BIOGRAPHY

1834 James Abbott McNeill Whistler was born on July 11, at Lowell Massachusetts.

1843 The family moved to Russia, where his father worked as a consulting engineer for the St. Petersburg to Moscow railroad. Whistler received his first art instruction in St. Petersburg.

1848 Because of bouts of rhumatic fever, he spent most of the year with his older half-sister, who was married to Seymour Haden, a surgeon and an accomplished amateur etcher.

1849 The family returned to the United States after his father died. Whistler enrolled in a school at Promfret, Connecticut. First known painting: *The Artist's Niece*.

1851 Arrived at West Point on June 3. He was dismissed in 1853 because of his poor academic record and his demerit points.

1852 In the fall he was admitted to the drawing classes conducted at West Point by Robert Walter Weir. He was top of his class in drawing.

1854 Unsuccessful attempt at reinstatement at West Point. In July he went and visited the Winans family in Baltimore, who was living in a palatial mansion surrounded by gardens containing classical sculptures. He spent his time sketching in the drawing office of the Winans locomotive factory. In November he received an appointment to the United States Coast Survey Office. He was first assigned to the Drawing Division, then, in December, to the Engraving Division, where he took his first lessons in etching.

1855 Resigned on February 12. He returned to stay with Tom Winans, who encouraged him in his artistic ambitions and began to assist him with loans for materials. He left for Europe soon after his coming of age. He spent a few weeks in London and arrived in Paris on November 3. He enrolled in evening classes at the Ecole Impériale et Spéciale de Dessin and spent much of his time in the Latin Quarter.

1856 *Vie de bohême* in Paris. In June he entered the Académie Gleyre and soon after started to copy paintings at the Louvre.

1857 Joint etching venture with three English artists working in Paris, Edward J. Poynter, L. M. Lamont, and George Du Maurier. In September he went to see the Manchester Art Treasures exhibition, where he could see an outstanding selection of Dutch seventeenth-century paintings and etchings.

1858 First series of etchings while recovering from an illness at his brother-in-law's house in London. In April he returned to Paris, where he began etchings of working women in the Realist vein. In the summer he made an artistic pilgrimage to Amsterdam in order to see the works of the seventeenth-century Dutch masters. He traveled through Alsace to Strasbourg, then followed the Rhine to Cologne and continued on to Amsterdam, sketching in pencil and watercolor. On his return to Paris he met Henri Fantin-Latour, who introduced him to Alphonse Legros, Felix Bracquemond, and Edouard Manet. In November he went to London. Etching of *The*

French Set and of domestic genre prints. He began working on *At the Piano*.

1859 He returned to Paris on January 12. *At the Piano* was rejected by the Salon. Several trips to London, where two etchings were exhibited, his first works to be shown in England. He worked on etchings of the English landscape and the Thames. First drypoints. *At the Piano* was exhibited in François Bonvin's studio in Paris.

1860 Rented a studio in London, at 70 Newman Street. *Wapping, The Thames in Ice, Harmony in Green and Rose: The Music Room*, the latter being one of his last works painted in the manner of the French Realists. *At the Piano* was exhibited at the Royal Academy in London and received critical acclaim. His mistress, Joanna Heffernan, posed for several etchings, drawings, and paintings.

1861 Seascapes of Brittany. He met Edgar Degas.

1862 Moved to Chelsea. *Symphony in White No. 1: The White Girl* was rejected by the Royal Academy. Seascapes of the Basque coast. Beginning of his friendship with Dante Gabriel Rossetti.

1863 *The White Girl* was shown at the Salon des Refusés in Paris, causing a stir. He ceased to etch for seven years. In March he moved to 7 Lindsey Row in Chelsea. Trip to Amsterdam.

1864 *The Golden Screen, The Balcony, Rose and Silver: The Princess from the Land of Porcelain*, in which Whistler aimed at assimilating principles of Oriental art into his own work. He was introduced by Rossetti to Frederick Leyland, a Liverpool shipping magnate.

1865 Trip on the Rhine, followed by a stay at Trouville, where Courbet and Whistler worked together. Four seascapes. *Symphone in White No. 2: The White Girl* was exhibited at the Royal Academy. There he met Albert Moore, who had a great influence on him.

1866 Trip to Chile. Landscapes of Valparaiso and first paintings of night scenes.

1867 Night scenes on the Thames. He moved to another house in Chelsea, at 2 Lindsey Row. Break with Haden and Legros.

1868 First visit to Speke Hall, the Liverpool home of his patron Frederick Leyland.

1871 Publication of *The Thames Set*.

1872 *Arrangement in Gray and Black No. 1: Portrait of the Painter's Mother*, which the commitee for the Royal Academy was reluctant to accept, *Arrangement in Gray and Black No. 2: Portrait of Thomas Carlyle*. First paintings in the *Nocturne series*. *Nocturne: Blue and Silver — Cremorne Lights*.

1874 First one-man show at the Flemish Gallery in London. Portraits and Nocturnes. *Nocturne in Black and Gold: The Falling Rocket*.

1875–79 Etchings and drypoints of the Thames. His mother moved from London to Hastings.

1876 Participated in the exhibition of the Society of French Artists at the Deschamps Gallery in London. *The Peacock Room*. Maud Franklin became his mistress and model.

1877　Break with Leyland. Disastrous libel suit against art critic John Ruskin.

1878　Introduced to lithography. He moved to the « White House, » a house he had built on Tite Street in Chelsea. Published « Whistler v. Ruskin: Art and Art Critics. »

1879　Late Thames etchings. In spite of the commercial success of his etchings, he was declared bankrupt in May. He lost his house in London and many paintings were auctioned off. The Fine Art Society commissioned twelve etchings of Venice. He left for Venice in September.

1880　Etchings and pastels in Venice. Back in London in November, he published *The First Venice Set*, a series of twelve etchings, which was not well received by the public and the critics.

1881　Successful exhibition at the Fine Art Society of fifty-three Venice pastels. Paintings and etchings of London street scenes. His mother died.

1883　Exhibition at the Fine Art Society of fifty-one etchings: the balance of the Venice plates and a few London ones. The show was a critical failure but was greatly admired by other artists, including John Everett Millais and Camille Pissarro. He participated in the Second International Exhibition at the Galerie Georges Petit in Paris. *Portrait of Theodore Duret.* Oil and watercolor landscapes in Cornwall. Lithographs.

1884　Large one-man show of watercolors at the Dowdeswell Gallery in London.

1885　Delivered his « Ten O'Clock » lecture in London, setting forth his own aesthetic principles and attacking Ruskin's aesthetics. Traveled to Belgium, Holland, and Dieppe.

1886　Published *The Second Venice Set*: twenty-six etchings, with a sheet of « Propositions » stating Whistler's thoughts on etching. On June 1, he was elected president of the Society of British Artists, an exhibition society created at the turn of the nineteenth century to break the monopoly held by the Royal Academy. One-man show at Dowdeswell's: *Notes, Harmonies,* and *Nocturnes.*

1887　Published the Jubilee etchings: twelve small plates. Trip to Holland and Belgium in the fall: nineteen etchings to be published in the following year, including thirteen of Brussels. He took part in the Sixth International Exhibition at the Galerie Georges Petit in Paris. Published six lithographs, *Art Notes.*

1888　Exhibition at the Galerie Durand-Ruel in Paris. He married Beatrix Godwin on August 11. She was helself a competent artist and etcher. Trip to the Loire valley and the towns of the Touraine: *The Renaissance Etchings,* which were never published as a set. He participated in the International Exhibition held in Munich. The « Ten O'Clock » lecture was translated into French by Stéphane Mallarmé. Théodore Duret published « Whistler et son œuvre. »

1889　Large exhibition of oils, watercolors, and pastels held at the Wunderlich Gallery in New York: *Notes, Harmonies,* and *Nocturnes.* In August he traveled to Amsterdam, producing ten etchings that were exhibited the following year at the Grolier Club in New York and at Dunthorne's Gallery in London, where they were greatly admired by Bernard Shaw. Nine etchings were displayed in the British section of the World Fair in Paris.

1890–96　Worked on lithographs.

1890　Met Charles Freer, a patron of living American artists and a collector of Oriental art. Publication of an edited volume of Whistler's correspondence, « The Gentle Art of Making Enemies. »

1891　*Arrangement in Gray and Black No. 1: Portrait of the Painter's Mother* was purchased for the French national collection (4000 francs). *Portrait of Robert de Montesquiou.* Summer in Paris working on lithographs.

1892　Retrospective exhibition at the Goupil Gallery in London: forty-three *Nocturnes, Marines,* and chevalet pieces. He settled in Paris at 110 Rue du Bac, with a studio at 86 Rue Notre-Dame-des-Champs. Earlier in the year, he was awarded the Legion of Honor, thanks to the efforts of Mallarmé and Claude Monet. He started work on etched views of Paris. Took part in the second exhibition of the Société Nationale des Beaux-Arts and in the Sixth International Exhibition in Munich.

1893　Began printing the Paris views, but the printing of the twenty-three plates was not completed before 1899. He abandoned etching in favor of lithographs: twelve prints of Paris subjects. Trip to Brittany in July.

1894　His wife was stricken with cancer and she died two years later. Series of nudes. *Harmony in Blue and Gold: The Little Girl in Blue.* Series of portraits.

1895　Portraits of young women and children. Series of self-portraits. Spent time at Lyme Regis, Dorset.

1896　Abandoned lithography after his wife's death.

1897　*Rose and Gray: Geneviève Mallarmé.* Trip to Dieppe.

1898　Elected president of the International Society of Sculptors, Painters and Gravers. He opened a short-lived art school in Paris, at 6 Passage Stanislas.

1899　Series of nudes. Published « Eden v. Whistler: The Baronet and the Butterfly. » Trip to Florence and Rome. Summer at Pourville-sur-Mer, near Dieppe. A series of his etchings was given a special room at the Second International Exhibition at Knightsbridge in London. Trip to Holland and Ireland.

1900　Winter in London and part of the summer in Ireland. His health had begun failing in 1897, and after a long bout of illness, he sailed for Tangiers and Algiers via Gibraltar. He was awarded the Grand Prix for etching at the Paris World Fair.

1901　Fell ill in Marseilles. He sailed for Corsica in search for milder weather and took up etching there. Four plates survive. He returned to London in May and sold his house in Paris. Stay at Bath.

1902　Trip to The Hague with Charles Freer, where he suffered a minor heart attack. Leased a house at 72 Cheyne Walk in London.

1903　Died of a heart attack in London on July 17. He was buried in a little churchyard in Chiswick, overlooking the Thames. His grave is a few feet from Hogarth's.

1905　Major retrospective exhibitions at the New Gallery in London (750 works) and at the Ecole des Beaux-Arts in Paris (438 works).

1984　Hundred-and-fiftieth aniversary of Whistler's birth. Major exhibitions at the Freer Gallery in Washington, D.C., at the Hunterian Art Gallery in Glasgow, at The Los Angeles County Museum of Art, and at the Metropolitan Museum of Art in New York.

RECENT EXHIBITIONS

1951 *Whistler. Arrangements in Grey and Black.* Art Gallery and Museum, Kelvingrove, Glasgow.

1954 *Etchings, Dry-Points and Lithographs by Whistler.* The Arts Council of Great Britain, London. *Sargent, Whistler, and Mary Cassatt.* The Art Institute, Chicago. The Metropolitan Museum of Art, New York. Catalogue by Frederick A. Sweet.

1960 *James McNeill Whistler: An Exhibition of Paintings and Other Works.* The Arts Council of Great Britain, London. Knoedler Galleries, New York. Catalogue by Andrew McLaren Young.

1968 *James McNeill Whistler: Paintings, Pastels, Watercolors, Etchings, Lithographs.* The Art Institute, Chicago. The Munson Williams Proctor Institute, Utica, New York. Catalogue by Frederick A. Sweet et al.

1969 *James McNeill Whistler.* Nationalgalerie Staatliche Museen, Berlin. Catalogue by Andrew McLaren Young, Henning Bock, Jutta von Simson, and Robin Spencer.

1971 *From Realism to Symbolism: Whistler and His World.* Wildenstein and Co., New York, with Columbia University. Philadelphia Museum of Art. Catalogue by Allen Staley et al.

1976 *Whistler, the Graphic Work: Amsterdam, Liverpool, London, Venice.* Thos. Agnew & Sons, London. Catalogue by Margaret MacDonald.

1977 *The Stamp of Whistler.* Allen Memorial Art Museum, Oberlin, Ohio. Catalogue by Robert H. Getscher.

1980 *Whistler's and Further Family.* Glasgow University Library. Catalogue by Kate Donnelly and Nigel Thorp.

1983 *A Cultivated Taste. Whistler and American Print Collectors.* Davison Art Center, Wesleyan University, Middletown, Connecticut. Catalogue by M. Lee Wiehl. *La Femme. The Influence of Whistler and Japanese Print Masters on American Art. 1880–1917.* Grand Central Art Galleries, New York. Catalogue by Gary Levine, Robert R. Preato, and Francine Tyler.

1984 *Drawing Near: Whistler Etchings from the Zelman Collection.* Los Angeles County Museum of Art. The National Gallery, Washington, D.C. Catalogue by Ruth Fine. *The Etchings of James McNeill Whistler.* The Metropolitan Museum of Art, New York. The Art Gallery of Ontario, Toronto. Catalogue by Katharine A. Lochnan. *James McNeill Whistler at the Freer Gallery of Art.* Freer Gallery of Art, Washington, D.C. Catalogue by David Park Curry.

SELECTED BIBLIOGRAPHY

CATALOGUES RAISONNES

KENNEDY, Edward G. *The Etched Work of Whistler, Illustrated by Reproductions in Collotype of the Different States of the Plates.* New York: Grolier Club, 1910. Reprinted, San Francisco: Alan Wofsy, 1978.

KENNEDY, Edward G. *The Lithographs by Whistler. Illustrated by reproductions in photogravure and lithograph, arranged according to the catalogue by Thomas R. Way with additional subjects not before recorded.* New York, 1914.

LEVY, Mervyn and STALEY, Allen. *Whistler Lithographs: A Catalogue Raisonné.* London: Jupiter, 1975.

MANFIELD, Howard. *A Descriptive Catalogue of the Etchings and Dry-Points of James McNeill Whistler.* Chicago, 1904.

YOUNG, Andrew McLaren, MACDONALD, Margaret, SPENCER, Robin and MILES, Hamish. *The Paintings of James McNeill Whistler.* 2 vols. New Haven, Conn., London: Yale University Press, 1980.

WRITINGS BY WHISTLER

The Gentle Art of Making Enemies. London: Heinemann, 1890. Reprint, New York: G. P. Putnam's, 1953.

BOOKS

BACHER, Otto. *With Whistler in Venice.* New York: The Century Co., 1908.

BECKER, Eugene Matthew. *Whistler and the Aesthetic Movement.* Doctoral dissertation, Princeton University, 1959. Ann Arbor, Mich.: University Microfilms International, 1979.

BELL, Nancy R. E. *James McNeill Whistler.* London, 1905.

BENEDITE, Léonce. *L'Œuvre de James McNeill Whistler.* Paris, 1905.

BERGER, Klaus. *Japonismus in der westlichen Malerei.* Munich, 1980.

BLANCHE, Jacques-Emile. *De David à Degas.* Paris, 1927.

BOWDOIN, W. G. *James McNeill Whistler. The Man and His Work.* London, 1902.

CAFFIN, Charles H. *The Story of American Painting.* New York, 1907.

CAFFIN, Charles H. *American Masters of Painting.* New York, 1913.

CARY, Elizabeth Luther. *The Works of James McNeill Whistler: A Study, with a Tentative List of the Artist's Works.* New York: Moffat, Yard & Co., 1907.

CHISABURO, Yamada ed. *Japonisme in Art: An International*

Symposium. Tokyo: Committee for the Year 2001 and Kodansha International Ltd., 1981.

DODGSON, Campbell. *The Etchings of James McNeill Whistler.* London: Studio Ltd., 1922.

DUFWA, Jacques. *Winds from the East: A Study in the Art of Manet, Degas, Monet and Whistler, 1856–86.* Stockholm: Almquist & Wiksell. Atlantic Highlands, N. J.: Humanities Press, 1981.

DU MAURIER, Daphne ed. *The Young George Du Maurier: A Selection of His Letters, 1860–67.* Westport, Conn., 1969.

DURET, Théodore. *Histoire de James McNeill Whistler et son œuvre.* Paris: Floury, 1904, 1914. Trans. by Frank Rutter. London: G. Richards Ltd. Philadelphia: Lippincott, 1917.

EDDY, Arthur J. *Recollections and Impressions of James McNeill Whistler.* Philadelphia, London, 1903, 1904.

FLEMING, Gordon. *The Young Whistler, 1834–1866.* London, Boston: Allen & Unwin, 1978.

GALLATIN, Albert Eugene. *Whistler's Art Dicta and Other Essays.* Boston, 1904.

GALLATIN, Albert Eugene. *Whistler: Notes and Footnotes and Other Memoranda.* New York, 1907.

GALLATIN, Albert Eugene. *Portraits and Caricatures of James McNeill Whistler, an Iconography.* London, New York, Toronto: Lane, 1913.

GALLATIN, Albert Eugene. *Portraits of Whistler: A Critical Study and an Iconography.* London, New York: Lane, 1918.

GETSCHER, Robert. *Whistler and Venice.* Doctoral dissertation, Case Western Reserve University, Cleveland, 1970. Ann Arbor, Mich.: University Microfilms International, 1974.

GORDER, Judith Elaine. *James McNeill Whistler: A Study of the Oil Paintings, 1855–69.* Doctoral dissertation, University of Iowa, 1973. Ann Arbor, Mich.: University Microfilms International, 1984.

GREGORY, Horace. *The World of James McNeill Whistler.* New York: Nelson, 1959.

HARTMANN, Sadakichi. *The Whistler Book.* Boston: Page & Co., 1910.

HOLDEN, Donald. *Whistler Landscapes and Seascapes.* New York: Watson-Guptill, 1959.

HOOPES, Donelson. *The American Impressionists.* New York, 1972.

LANCASTER, Clay. *The Japanese Influence in America.* New York, 1963.

LANE, James Warren. *Whistler.* New York, 1942.

LAVER, James. *Whistler.* London: Faber & Faber, 1930, 1951.

LOCHNAN, Katharine A. *Whistler's Etchings and the Sources of His Etching Style, 1855–80.* Unpublished doctoral dissertation, Courtauld Institute, University of London, 1982.

LOCHNAN, Katharine A. *The Etchings of James McNeill Whistler.* New Haven and London: Yale University Press, 1984.

MACDONALD, Margaret. *Whistler and Mallarmé.* Oxford: Clarendon Press, 1959.

MCMULLEN, Roy. *Victorian Outsider. A Biography of James McNeill Whistler.* New York: Dutton, 1973.

MAUCLAIR, Camille. *De Watteau à Whistler.* Paris, 1905.

MEIER-GRAEFE, Julius. *Modern Art.* Trans. by F. Simmonds and G. W. Chrystal, 2 vols. London, New York, 1908.

MENPES, Mortimer. *Whistler as I Knew Him.* London: Adam & Charles Black, 1904.

NAYLOR, Maria. *Selected Etchings of James McNeill Whistler.* New York: Dover, 1975.

PARRY, Albert. *Whistler's Father.* New York: The Bobbs-Merrill Co., 1939.

PEARSON, Hesketh. *The Man Whistler.* London: Methuen, 1952. New York: Taplinger, 1978.

PENNELL, Elizabeth Robins and PENNELL, Joseph. *The Life of James McNeill Whistler.* 2 vols. Philadelphia: Lippincott. London: Heinemann, 1908.

PENNELL, Elizabeth Robins. *The Whistler Journal.* Philadelphia: Lippincott, 1921.

PENNELL, Elizabeth Robins. *Whistler the Friend.* Philadelphia: Lippincott, 1930.

POUSETTE-DART, Nathaniel. *James McNeill Whistler.* New York, 1924.

PRIDEAUX, Tom. *The World of Whistler.* New York, 1970.

RUTTER, Frank. *James McNeill Whistler. An Estimate and a Biography.* London: Grant Richards. New York: M. Kennerley, 1911.

SEITZ, Don Carlos. *Whistler Stories.* New York, London: Harper & Brothers, 1913.

SICKERT, Bernhard. *Whistler.* London: Duckworth, 1908.

SINGER, Hans Wolfgang. *James McNeill Whistler.* London: Siegle, 1905.

SPENCER, Robin. *James McNeill Whistler and His Circle.* Unpublished M. A. Report, Courtauld Institute, University of London, 1968.

SPENCER, Robin. *The Aesthetic Movement.* London: New York, 1972.

SUTTON, Denys. *Nocturne. The Art of James McNeill Whistler.* Philadelphia: Lippincott. London: Country Life, 1963.

SUTTON, Denys. *James McNeill Whistler. Paintings, Etchings, Pastels and Watercolours.* London: Phaidon, 1966.

TAYLOR, Hilary. *James McNeill Whistler.* New York: Putnam's, 1978.

THOMAS, Ralph. *A Catalogue of the Etchings and Drypoints of J. A. M. Whistler.* London: J. R. Smith, 1874.

WAY, Thomas Robert and DENNIS, G. R. *The Art of James McNeill Whistler.* London: Georges Bell & Sons, 1903.

WAY, Thomas Robert. *Memories of James McNeill Whistler.* London: Lane, 1912.

WAY, Thomas Robert. *The Lithographs of Whistler.* New York, 1914.

WEDMORE, Sir Frederick. *Whistler's Etchings, A Study and Catalogue.* London, 1886.

WEINTRAUB, Stanley. *Whistler. A Biography.* New York: Weybright & Talley, 1974.

WEISBERG, Gabriel P. *et al. Japonisme: Japanese Influence on French Art, 1854–1910.* Cleveland: Cleveland Museum of Art, 1975.

LIST OF ILLUSTRATIONS